practising simplicity

*For Daniel, Che, Poet,
Percy and Marigold,
my best travelling
companions*

*And for Auntie Jenny;
you were with us
all the way*

JODI WILSON

practising
simplicity

small steps
and brave choices
for a life *less* distracted

murdoch books
Sydney | London

Contents

Dear reader,

This is a letter and also an invitation, one written without presumption or expectation.

As you will learn, this story is about my big life change, which involved selling most of my belongings and packing up my family to travel Australia in a caravan. I was the least likely candidate for such an adventure—a self-confessed homebody with a fear of change—and so, while many of the pages in this book are dedicated to sharing my nomadic experience, most of it is actually about the little everyday things, the simple practices we create for ourselves, that carry us from one moment to the next.

I have spoken more about my downfalls than successes in this book. I did so in part to be honest, but also to accurately tell my own story, which has never been linear, but rather, a messy scribble of a journey punctuated with a fair amount of fear and anxiety. That said, in particularly challenging times, simplicity has brought me back to my ground. I've found clarity and purpose in the simplest habits and rituals, and as I've learned, over many years of motherhood and a few years on the road, it really is the tiny morsels of joy that remind me what matters, that prove we don't need a lot to live well.

When I feel a little complacent, perhaps even lost, I've always sought comfort in a book and the voice that rises off the pages. I hope this book is that for you—something you can reach for when life feels a little too much, when you feel like you've lost your way, or when you're in need of inspiration. Whether you're reading this in your favourite bookstore, in a dark corner of the library, on the bus or tucked up in bed, I want you to know that change is always possible, if only we believe in it, if only we believe in ourselves.

Jodi

Chapter 1

Choose your own
adventure

The theatre was dimly lit, the quiet punctuated by protesting toddlers who had no intention of sitting in their seats. We were one of many sets of bedraggled parents who had spent the afternoon preparing their children for a school performance at witching hour; dinner was early, the baby was unsettled and we had misplaced two pairs of shoes. Together we arrived in a cloud of hairspray and frazzle, calming nerves and mustering enthusiasm for the two-hour performance ahead of us.

Our son's class was dressed in a hodgepodge of costumes pulled from the backs of wardrobes, but together they told a unified story. One by one they recited lines from legendary Australian children's author Alison Lester's picture book *Are We There Yet?*, the true story of her family's three-month road trip around Australia in a camper trailer. We had owned the book for many years and often read it at bedtime, its pages now crumpled and worn and well-loved.

As I watched my firstborn on the stage, my fourth baby was nestled in a sling on my chest, her pout particularly pronounced as she dozed. I had spent the first three months of her life purposefully soaking her in, memorising the details of her face and her milk guzzle, fiercely inhaling her breath and newness because I knew it was all so fleeting. She would be on the stage in a few short years and I would be the proud, nostalgic mother, in awe of her growth and simultaneously grieving for the years that were behind us, her littleness etched into photos and videos and the pieces of my mind that I had filed away for safekeeping.

The story on the stage took us from the coast to the desert, where the sun beat down on the family who travelled on freeways and red dirt roads and into all kinds of adventures. They sat around campfires laughing at bad jokes,

Practising Simplicity

gazed out the window on long driving days and spent every waking and dreaming moment together, in all sorts of places all over Australia.

'We could do that,' whispered my partner Daniel, eyebrows raised and hopeful. 'We could go on a road trip around Australia.'

'Yes!' I replied, nodding for emphasis in case he hadn't heard.

I will never forget the pleasant confusion on his face or the undeniable mix of fear and excitement that pummelled through my body as I realised what I'd just said. Could we really do it? Pack up our lives and hit the road with a rough plan and only the essentials? Spend our hard-earned house deposit on a car and a caravan, and trust that my freelance work would keep us going? It was the very opposite of how we currently lived: darting from home to school and back again, juggling city commutes with extracurricular activities, squeezing in weekends with no plans because the weekdays were full and exhausting and I constantly felt like I was playing catch-up.

A family of six road-tripping around Australia would be a spontaneous adventure that would free us from the sense of obligation that dictated so much of our lives. But I am not an adventurer. I'm rather risk-averse; I prefer to know what's coming next so I can have a sensible plan and stick to it. Predictability is always my preference. But still, I wondered: what if? Earlier that same day, we had met with a bank manager about applying for a mortgage. House prices had soared in our part of the world and we were interested to see how much we could borrow. He'd printed out the figures for us and the reality was bleak. After years of saving and months of consideration, we could buy a house that needed significant work, in a suburb we didn't love, and spend the next thirty years paying it off. It would mean continuing to live like we were: juggling and commuting and existing in a cycle of work and sleep, work and sleep. We struggled to make sense of it.

Later that night we carried four sleeping children from the car to their beds and tucked them in tight because it was still cold for late spring. I put the kettle on and wandered over to Daniel, who was already looking at caravan listings on Gumtree.

'Are we really going to do this?' he asked.

'Yes,' I said. 'I think we are.'

The days that change our lives are sometimes rather ordinary. There aren't neon arrows lighting the way, or confetti to celebrate decisions made. Instead, there is the simple, profound acknowledgement of change realised—long exhalations, a quickening of the heart, the splendid dizzying of knowing that you're on a new path. I felt all these things coupled with the persistent hum of fear and overwhelm, but instead of running from a big decision like I usually do, procrastinating till it disappears into the ether, I ran towards it, arms wide, gaze forward, knowing that I was ready for everything this change meant. Scared, but ready.

In the eight months between that day and the evening we left our house in the suburbs towing our 7-metre caravan, there were countless moments when it felt too risky and too daunting and just too big. Honestly, I wanted to cancel our plans on every single day of those eight long months. But I'd said yes and in that moment there was no fear and insecurity, just the profound, affirming sensation that it was good and it was right.

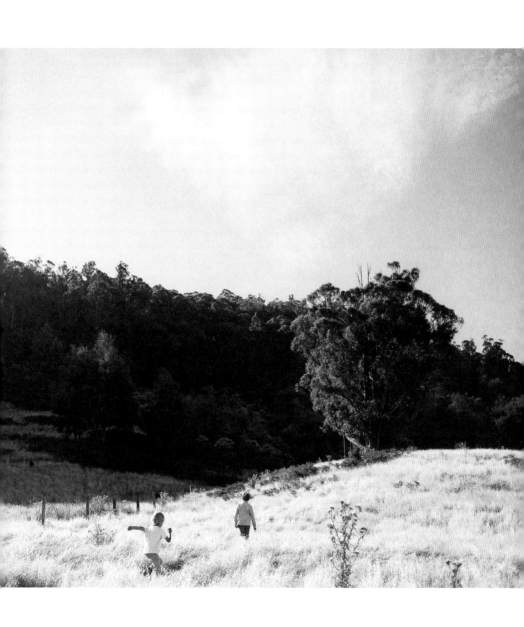

Choose your own adventure

Was this my moral nerve? A stubborn act in defiance of my anxiety: the fear that had kept me complacent and unchallenged for over a decade? Was this being fed up with the mundane, the very thing I had basked in, even celebrated, for as long as I could remember? I wasn't sure, but what I did know was that I was in a golden pocket of time—a real moment of choice and change—an opportunity that would pass me by if I didn't grasp it. This was the 'big magic' that Elizabeth Gilbert talks about in her book of the same name—the idea that wafts into your life with intention and purpose, plants itself in your mind and your heart, and waits for you to take hold of it with both hands. It really was surreal, a mere moment of magic, but it was also digging down and sitting with my deepest, truest self, which is never not confronting. I listened, I resisted and then I acted. Every single time I thought about cancelling the trip, I reminded myself that much greater than the relief of letting this big life change go was knowing that I would be ignoring my intuition to do so. There may have been fear but there was also an undeniable truth and a rousing belief that this was the only way forward.

Road-tripping around Australia was a surprising choice for me at the time, my fourth baby in my arms, dreams of home ownership almost realised. But if I consider the whole picture, the idea had been floating around since I tore a page from a magazine and stuck it on my bedroom wall fifteen years earlier. It was a photo of a girl, standing in a small, vintage caravan, a linen tea towel hung over the door, a wooden broom leaning against the window. It was a picture of simplicity and adventure, albeit styled, and it enraptured me. I was so enthralled by the idea of simple travel that I spent far too many hours researching books when I should have been stacking the shelves of the bookshop I worked in. I ordered stories on nomadic living and the Romanies and added the biographies of female travellers to my reading pile. Years later, in our first family home, there was a pink pinboard in the kitchen so when I was unpacking boxes and came across the girl in the caravan, I pinned it to the board and occasionally looked at it while I stirred dinner, my firstborn perched on my hip.

Choose your own adventure

I had ruminated on that picture and what it meant to me for close to two decades before I acted on it. Some may say that I'd unintentionally created a manifestation board; perhaps it was just a charming coincidence. Mostly, I think the concept of caravan travel had been there for years and while it hadn't been front of mind for a long time, it sat just below the surface, waiting for an opportunity to be realised.

I think we've all got these dreams tucked away somewhere, brewing. They may come to mind when we're thinking about what could be or what we most want. When we reach those points that push us to think about our true purpose, that's when we tap into the ideas and inspirations that we've filed away for another time. If we are privileged enough to live with choice, we have the opportunity to embrace adventure: the unusual, the thrilling, the daring. It looks different for everyone, of course, but it's also a path to purpose, of working out who you are, what you desire and where you belong. And once you figure it all out? Hold on to it, come back to it, let it guide you forward.

Choosing new adventures for ourselves seems like such a frivolous, childlike notion, but I honestly believe it's how we instinctively navigate the world. But, as with so much of our childhood—tree climbing, mud pies and make believe— we lose sight of it as we grow. We get caught up in the rush and the race, carried along without awareness, until the day when something shifts and we step back to see where we've landed. It's here, in this moment, that we tune in and perhaps realise that we've wandered too far from the path. Is this what lost feels like? That feeling of being unsettled and knowing that something's not quite right, even though you're standing in your normal and you've been there for years? For me it felt like frustration and complacency; I was unmotivated, uninspired and, frankly, quite angry. I pulsed agitation. What I knew, more than anything, was that I needed to shift everything about our life and walk in the opposite direction to what we'd planned. So, we sold 80 per cent of our belongings and spent our house deposit on a four-wheel drive and a caravan.

While I knew what the start of our road trip would look like, I had no idea how we were going to get to that point, nor did I know what would happen once we had set off, along the highway. When people asked me what we were doing and where we were going, I would rattle off my flippant, highly unresearched plans, which, in retrospect, were the largest and wildest overestimations of my life. But what I really wanted to scream to all those people who asked questions was: I have no idea what we're doing or where we're going but we're doing it anyway and if I think about it too much I won't do it! So I just focused on the beginning, getting there one step at a time. In the words of the great explorer Amelia Earhart: the most effective way to do it, is to do it. So, I did. I adopted the mentality that we'd work it out as we went along, which I now know is the very essence of nomadic living. As with most adventures, it was never about the destination but about letting go, shedding our possessions, practising simplicity on a new level of less and simply spending time, together.

Saying yes to this adventure meant also realising that I was responsible for my contentment. The adventure wasn't so much about where we were going or what we were doing, but it had everything to do with the way I saw the world, the way my perspective shifted, the way I settled into my body as I stood barefoot on the sand, the ocean in front, the van behind, a gaggle of kids shrieking as they raced towards the waves. It has always been about these moments—some lasting mere minutes, others stretching out for days—a strange time capsule of experience and adventure that's now a collection of memories. We didn't follow a path but zigzagged instead, pulled by curiosity and consequence, invitation and community. It didn't really matter where we were going, it was the act of heading off to somewhere, anywhere, and having the freedom to do so. That was our adventure, that's where I needed to be, in the space where spontaneity lives—the breathing space that's free of obligation and plans.

The greatest adventures
 are the ones we embark
on personally:
to *dig deep*, confront our fears
 and move forward,
often in a 'three steps forward,
two steps back' kind of way.

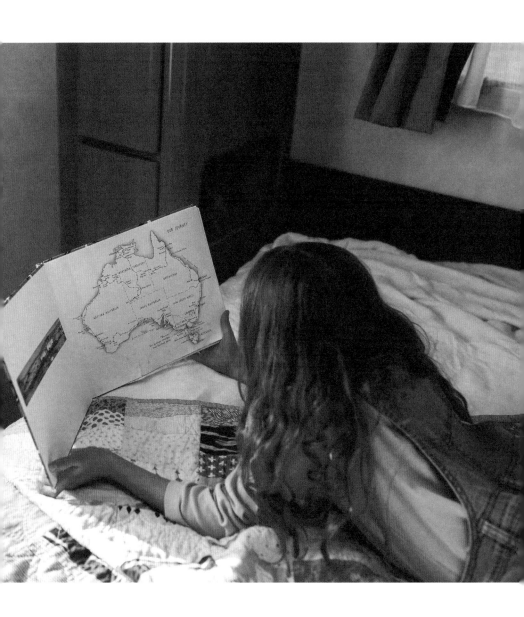

Choose your own adventure

It was when we landed in the red dirt of Uluru that I learned the most pertinent lesson. The traditional owners, the Anangu people, encouraged us to connect with the land instead of attempting to conquer it. It was a simple and polite plea borne of a deep, ancient knowing of and reverence for the land, and yet it's never been more pertinent as we experience the brutal repercussions of a conquered world. If I have gleaned anything from slowly travelling Australia and taking the time to sit in the landscape, sit with nature, be still and quiet and listen, it's this: connection is how we make sense of the world. It's also how we make sense of ourselves.

For me, bearing witness to the land, carving out the time to be with it, brought me back to my centre. It slotted all of my priorities into place. It allowed me to realise what I most want and need. And while I changed my entire life to come to this realisation, I also believe it's something you can discover in your own way. Ocean swimmers, weekend hikers, backyard gardeners—they know this feeling, and it's why they return, again and again, to the sea and the mountains and the patch of dirt beyond the back door, to connect and be and reshuffle their priorities, which so easily get muddled in the daily juggle. This is practising simplicity in a world that champions productivity: establishing daily rituals, getting grounded, connecting with

If we have choice,
we can make *change*.

nature and then moving forward intentionally, buoyed by a sense of purpose and belonging. These are the simple things in life, the ordinary yet remarkable things we pine for when we feel overwhelmed by uncertainty. My family road trip was a steep, joyous, messy, life-changing experience. It also proved to me, time and time again, that the greatest adventures are the ones we embark on personally: to dig deep, confront our fears and move forward, often in a 'three steps forward, two steps back' kind of way. It is not a linear path. There are often hurdles, but leaping to the other side is always worthwhile. For us, that meant letting go of everything that was comfortable and predictable in our lives and embracing spontaneity and the unknown.

When I reminisce about all our unforgettable experiences and the moments that shine golden, I also see the life that happened between those peaks. Among the postcard captures of family adventure were all the mishaps, arguments and tantrums you would expect from six people living in a caravan on the road. The highlights carried us along, rejuvenating our desire to explore and experience, but the gritty life on the road that left us covered in sand, salt and red dirt was where I felt most content. And it was here that I realised: we get to write our own story. If we have choice, we can make change.

Chapter 2

What is

simplicity?

Simplicity is a modern-day revolution, a revolt against a world that lauds productivity, a quiet, revered acknowledgement of our smallness. It requires our attention, our empathy and our trust. But mostly it requires us to be aware, to care.

Perhaps it sounds a bit too serious, but I don't think we can talk about simplicity without connecting it to the natural world: the one that's in crisis, the one that desperately needs us to make changes, the one that has pushed us—and will continue to push us—to the edge. Living simply, in tune with nature, is the most natural thing we can do. It is also often the most challenging, but in that challenge is the joy, the contentment, the deep, permeating sense of purpose. And it's for that reason that I continue to practise it, even if it looks messy and disjointed, even when my small actions seem inconsequential. As the inimitable American author Annie Dillard says in her book *The Writing Life*: 'How we spend our days is, of course, how we spend our lives.' I know that today, and next month, and for the rest of my years I want to live intentionally, bravely, creatively and respectfully. I want to be aware of the simultaneous power and fragility of the natural world, and reflect on my place within it; to go to it when I want to connect; to be held and rejuvenated, and reminded of what matters.

The concept of simplicity has had many different guises since I was first introduced to it fifteen years ago. I spent time living in an ashram, a yoga community tucked into a valley not far from my home town on the Central Coast in New South Wales. It was there, one humid summer, when the air was heady with eucalypt and incense, that I listened to three swamis discuss non-attachment in a room that was bare aside from a candle and a floral offering to the deities. They may have been referencing non-attachment in regard to our achievements and also our belongings, but at the crux of their message was the encouragement to honour our intrinsic needs, to let go of our distractions, tune in and pay attention—and then act.

In Sanskrit, 'ashram' means refuge or retreat, and it is exactly these things: a place for people to go when they have lost their way, a place that offers reprieve and quiet when the world makes you weary. Everything that happens on any given day at the ashram is an opportunity to practise mindfulness. It is strict, but it's also a welcome guide when the endless choices of daily life become overwhelming, when the mental load feels too heavy. Each day begins with a chanting alarm, calling the village of bowed and silent blanket-clad yogis to the main hall to collectively practise asana and pranayama in the stillness of the morning. Intention is formed in the quiet of the dawn, before we speak or eat or plan.

It is also a place of austere simplicity, free of clutter and distraction. This intentional minimalism exists for a few reasons, but mainly because when we are distracted by the trivial and unnecessary, we find it difficult to stay present. This is all very good in an ashram environment, but when I left the ease of its confines I realised rather quickly that decluttering my home and my life of all their distractions was neither practical nor possible. How could I combine what I had learned about simplicity—the strict and intentional minimalism of the ashram—with the reality of messy family life that was inevitably cluttered with crumbs and laughter and miscellany? And was that even necessary, or was simplicity something I could practise on my own terms?

So, I started reading stories from those who championed simple living: vegie gardeners, frugal homemakers, nomads and monks. The crux of their experience was that simplicity is mostly about our focus and intentions; it is ever-changing, but also a profound step towards doing what's best for the planet and for ourselves. There aren't any rules or expectations, but if you are willing to listen, ask questions, make mistakes and stay aware, you'll discover a meaningful way forward by ultimately relishing the present moment.

Living simply cannot be defined by one perspective or experience. It isn't work that can be completed because we're not seeking a finished product. Indeed, it looks different for all of us. From the beginning I knew simplicity was not something I could achieve or perfect; I didn't want to strive for it or add it to my to-do list. So, I started to consider it as an attitude, one that often needed tweaking, and that occasionally lapsed; one I returned to when I felt disoriented and unmotivated. By embracing it as a mindset it became a daily habit and the more I practised it the easier it became. Like all good habits, it was an anchor to ground me and a compass to direct me.

My exploration of what simplicity means to me has been a long, slow road intertwined with over a decade of motherhood, spurred by interest, inquisition and the pressing need to do something—anything!—to preserve the natural world. But also, to remind myself over and over again that where I find contentment, what makes my life meaningful, is not grandiose successes but the simple, ordinary things that I do each day.

When we find perspective,
 when we practise simplicity,
 we learn to see and then embrace
 the beauty of our ordinary,
 remarkable lives.

Simplicity, I realised, started with my head and my heart, not my cluttered cupboards. That is what the swamis were talking about: the practice of mindfulness that prompts clarity, awareness and intention. Practising simplicity is essentially about letting go of expectation and making mental space so we can start where we are, with what we have.

And while the world may not be slowing down or simplifying, you can. And you can start by letting go of obligation and settling in to listen to what you most want, to the intuition that sits within and is often silenced by expectation. This is where creativity lives, where we explore possibilities and make plans that are daunting and exhilarating and could very well change our path. This is where we ponder how to live, where we wonder if we could be doing it all differently, in a way that feels better, more authentic, more ... honest. This is the hard stuff, the messy grapple, the tug of the heart and mind that comes before we leap. It's trust and surrender and, sometimes, going against the flow to make choices that aren't always considered progressive.

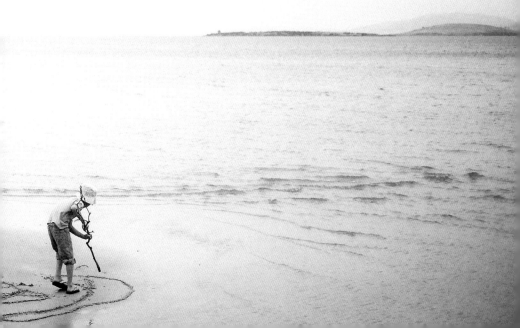

Choosing less, going slow and prioritising our presence over productivity is in stark contrast to the values of our contemporary society. But we can do it if we take small, considered steps forward. The big picture may inspire us, but we can only get there if we are aware of what we're doing today, in this moment, and make mindful choices about the little things, like where we shop, what we buy, what we choose to go without, where we go when we feel agitated, defeated or in need of clarity. Simplicity is celebrating the ordinary work we do each day—making tea, stirring porridge, relishing an afternoon nap, reading a bedtime story—and recognising it as a beautiful, worthy, valuable part of our life.

I know that moments of joy can be hard to find, especially in times of angst or sadness, when the world is racked by illness and uncertainty, riven by racism and unrest. But despite the big, undeniable stuff, life keeps going. Babies are born and we gather with those we love, we cook and eat and play, we long for our children to stay little and in the same breath we wish more than anything that they grow up and live well. We wash the dishes and hang the washing and open a fresh, new novel, and it's these things—on their own and collectively—that we dismiss if we rush through life distracted. The joy fades into the background unless we are present, aware and awake to this moment in time, feeling our breath as it moves in and out of our body, looking up to the big sky that sings from above and calls us to stop what we're doing, marvel at its greatness and shift our perspective.

It was the sky that I turned to during a particularly challenging week on our travels when we were stuck with a broken engine and an exorbitantly expensive bill waiting to be paid. In a

What is simplicity?

Practising Simplicity

low-cost camp just outside of Launceston, when the children were getting ready for bed and I was still outside, soaking in the late twilight of mid-summer in Tasmania (where the sun doesn't set till about 9 pm), I looked up to see a murmuration of starlings, a hypnotising flock of birds, flying as a shape-shifting cloud in the gloaming.

They sung and dived like it was the greatest show on earth and I stood there, still, mouth agape, eyes wet for the sheer fleeting beauty of it all. If I listened closely, I could hear the air move around them, in great walloping gushes that I felt in my heart as an almighty moment of awe. This was it! This is what we're here on this earth to marvel at, to share with each other, to connect with. This is what exists if we stop long enough to notice, if we deliberately seek it out and wait, patiently listening and watching.

The world is abundant with profound goodness; we just need to learn to recognise it, bask in it and seek it out when we feel disenchanted. We need to live in a way that preserves and sustains it. All of it. This is my daily work and perhaps it's yours, too. I practise it because I have a tendency to focus on the shadowy aspects of life. I can be jealous, critical, self-doubting, anxious, fearful and melancholy. While I know that the darkness and light will always exist—we can't have one without the other—and we need the dark for rest and regeneration, seeking the light is a little like seeking perspective, for me. By practising simplicity, I am reminded, daily, that I can go into nature and find hope, or discover it in the pages of a book or the hands of my children. I know what works when I feel off-kilter, when I feel hopeless at the state of the world, or when I feel like I need to realign my focus to find my purpose.

So, what if you let nature draw you back to what matters? And what if you discover that in the simplest things there is joy, and that joy can permeate every other aspect of your life? It can slowly weave its way in, altering your mindset and shifting your priorities, so that you find that quiet contentedness

in choosing less, choosing well and valuing things so they last, even when they are worn and old.

As my understanding of simplicity has grown and changed, it has also reminded me, regardless of where I am and what is happening in my life, that all I really need to do is be here now.

Be where *you are.*

You can start here, too. There isn't one clear-cut path to living simply, but by starting with the small things we do each day, we come to realise that change is simply about choice—choosing to care and take responsibility for doing what we can, wherever we are. Change happens because of the quiet yet relentless work of ordinary people who adapt regardless of what is happening in the world. I think the past few years have taught us, unequivocally, that we are all adaptable and far more resilient than we give ourselves credit for. In the same breath, it's important to acknowledge our personal and collective dismay and exhaustion— it's big, isn't it? We've been pushed to the edge. What we do next is a good question to ask. What will you choose?

I understand why it feels overwhelming. We've been sold simplicity as a lifestyle, an aesthetic and a world-changing trend, but we're left wondering if matching glass jars and cloth shopping bags are really it. Indeed, the steps towards big change seem so sketchy and, a lot of the time, feel like a guise for yet more consumerism and decisions. I think it starts with choosing to care. Simplicity has never been about separating our belongings into a 'keep' and 'donate' pile and calling it a job well done. It's daily work and, therefore, life work.

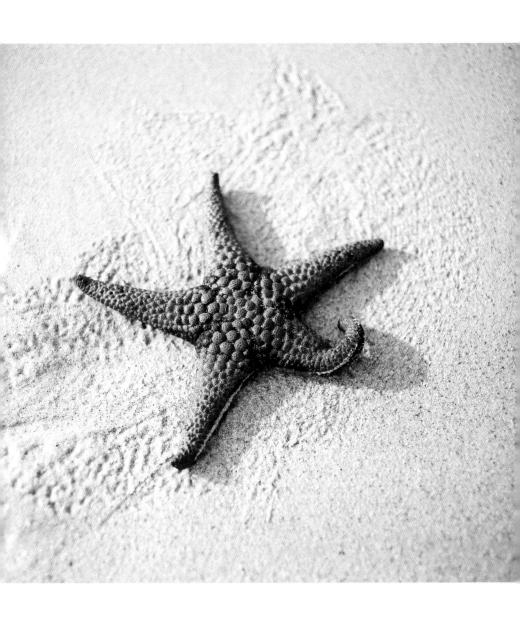

What is simplicity?

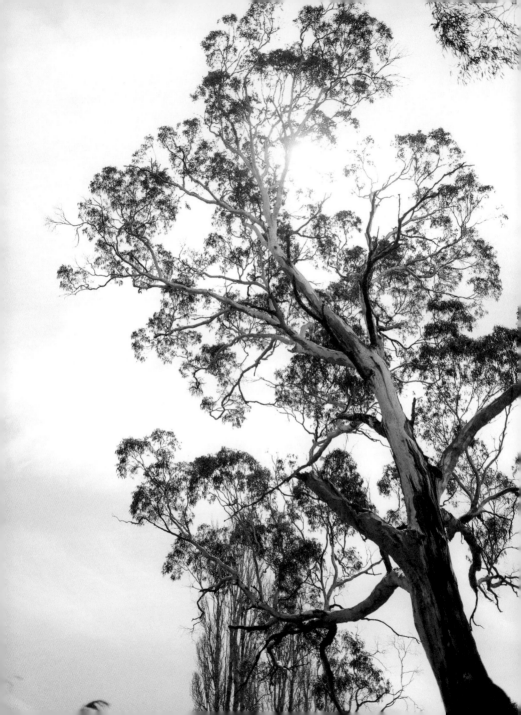

And when you start caring about the little things that you do each day (using up the wilted vegies in the bottom of the fridge, remembering your re-usable coffee cup, picking up rubbish, divesting your money), you realise that the big life changes are just a few steps on from where you are now. It is a matter of building momentum, learning from your community, living authentically and moving forward with hopeful action.

For me, recognising my privilege has been a significant part of the process. I believe, and perhaps you do, too, that if we are privileged enough to have choice then we have a responsibility to make choices that bring about change. While I'm inspired to turn my small yet meaningful actions into daily habits, I can't ignore the big picture. I'm spurred to stay informed, to be aware and awake to our politics and the choices that are being made for us. But just because lasting change needs to occur on a systemic level, it doesn't dismiss the small contributions we make each day. Grassroots simplicity is world-changing, and if you've been practising for a while you'll know in your heart that it's life-changing, too.

When I feel disenchanted by the fear of loss, the doom of politics and the snail's pace of systemic change, I am inspired by the resilience of nature. It quells my tendency to angst. It settles my nerves and shifts my thought patterns. Mostly, it reminds me that my small worries are inconsequential. In the big skies and old trees, in the dandelions that persist by poking through the concrete, there is perspective. It's there regardless of season or location, without judgement or expectation.

When we find perspective, when we practise simplicity, we learn to see and then embrace the beauty of our ordinary, remarkable lives. It's there already, if you want to stop and look around you. It's in the washing that's hanging on the line, it's the posy of flowers picked on your neighbourhood walk. It's a cup of tea in the quiet of the morning before anyone else wakes.

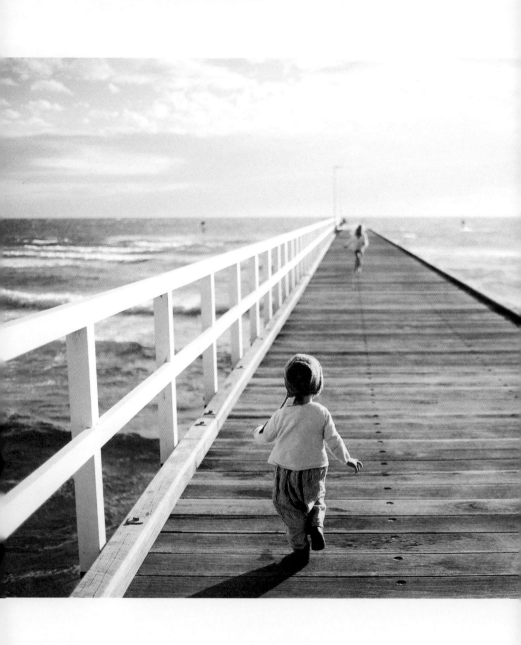

What is simplicity?

Gratitude helps to
shift the balance,
if only slightly,
from dark to *light*.

It's in the glorious mess of life that rarely goes to plan, is often mundane and exhausting, but continues on regardless. It is the light and the dark, the work and the rest, the expansion and contraction, the turning of the seasons and the acknowledgement of the long days and the short years.

I have learned that my experience of life—normal, daily life—is enhanced by slowing down and being mindful. When I reflect on the rich goodness of life, I don't often recall the extraordinary moments. I remember the quiet contemplation of the in-between, the moments I grasped and cherished because they were potent reminders that the simple things really are worth celebrating and the seasons of life are fleeting: newborn mews, the winter sun, the crash of waves, singing in unison to a road-trip playlist, a cup of tea brought to my bedside, the bubbling of homemade broth, a cosy blanket, flames against the night sky, a kiss.

Countless studies prove that gratitude is an antidote to anxiety; the two can't exist in the mind at the same time. Gratitude helps to shift the balance, if only slightly, from dark to light. But simplicity is more than that—it's being grateful, yes, but it's also being proactive. It's learning to see the grace, the magic and the wonder in the things that we encounter every day—it's paying attention, getting into the grittiness of life and musing on the minutiae. And then? Choosing a life that lifts those things up into the open, acknowledges them, praises them, saves them.

Practising simplicity is an act of gratitude and a service to the natural world; it's a prayer of thanks, and one of hope, too.

Chapter 3

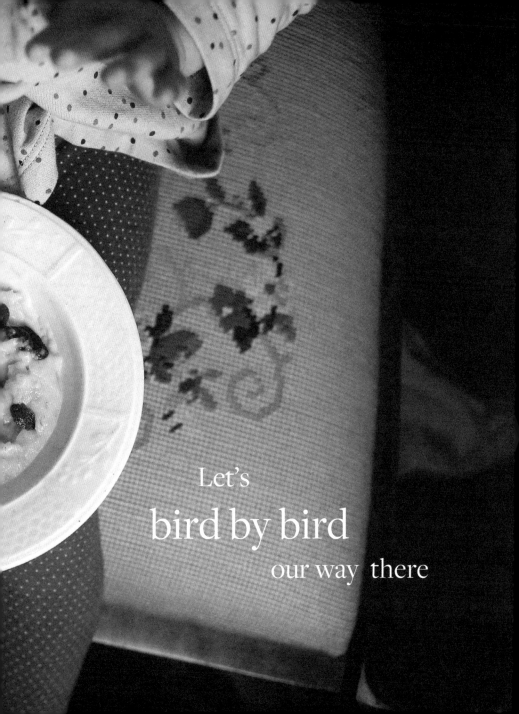

Let's
bird by bird
our way there

We had owned Alison Lester's book *Are We There Yet?* for years; my children were enamoured with the quirky observations of the young narrator and the colourful illustrations of sharks and crocodiles and spindly-legged children standing in the red desert. I had developed an affinity with the mother, who worries about getting lost in the middle of nowhere and demands that everyone wear sunscreen and hats. We had read it often, curled up on the bed for story time, but, until the evening of our son's class performance, we never thought that it could be our story, too.

Sitting between this night and the evening that we finally hit the road was the biggest to-do list of my life. I have always been an avid list-maker with a tendency to write more lists than I complete, but this one required reams of craft paper, a thick, black marker and a blank wall in our living room. We created it early in the planning process because doing so made the whole thing seem like a tangible life choice and not some frivolous idea we'd dreamt up on a whim. We had a list and that meant we were serious.

In reality, the 'list' was a relatively blank piece of paper with a few headings: To Do, To Sell, To Buy. Making a road-trip list required foresight and some knowledge of caravans; I had neither. So, instead, I wrote: Linen cupboard. Books. Children's clothes. And then I made a cup of tea, thinking that perhaps there'd be answers in the tea leaves, hoping to quell the dread with the excitement I'd felt when I said yes. I knew I was at the beginning of a stage that required big decisions and hard work, and that there was no easy way to get to the other side. Frankly, there was a lot to let go of and I had no idea where to start. We were consciously choosing a simpler lifestyle, but that simplicity required a foundation of work before

Practising Simplicity

we even began: a long list of decisions to be made and possessions to let go of. On the good days it seemed achievable, sometimes even thrilling, because I finally had the motivation of a firm deadline and the boundaries of a tiny home to consider. But on the hard days it felt like wading through mud and clutter, with a baby on my breast and a gaggle of hungry, bored kids at my feet.

There was no clear path between living in a three-bedroom home and moving into a caravan to road trip around the country. We were letting go of everything predictable and comfortable and good to leap into a lifestyle we knew nothing about. This is the kind of process that excites those who thrive on spontaneity and risk, but blankets people like me with anxiety and resistance. Those who err on the side of caution and restraint don't naturally embrace change; we feel hindered by it. We grapple and fight and hide, and it feels impossible to move forward. One morning, I woke up with the realisation that I was stuck in a vicious cycle of resistance and fear that was paralysing me. I literally felt frozen, so overwhelming were the tasks ahead of me. I've since learned that this is a natural response for those of us who tend to freeze instead of fight or flee in the face of something that shocks us. I needed to find the courage and grit to at least start making progress on this unknown path I'd chosen for myself. But courage and grit didn't feel very accessible at that stage; they were the traits of great adventurers, not the girl standing in front of a wardrobe trying to separate the joyous, practical things from everything I'd forgotten I even owned.

I desperately didn't want to do this part of it. I didn't want to sort through a three-bedroom house and fit the remainder in a

caravan. I didn't want to list things and sell things and figure out what to keep and what to donate. Ultimately, I didn't want to let go of everything that was certain and sure and comfortable in my life. But I also desperately wanted what was on the other side of that discomfort, and I knew that in order to get there I needed to surrender to the process. One evening, when I should have been packing books, I got comfortable on the floor beside the bookshelf and started re-reading Anne Lamott's *Bird by Bird*, in which she shares her advice for writing and for life, encouraging a small and steady approach to both. She recalls her father's advice as her brother struggled through a school project on birds: *Just take it bird by bird.*

I knew the only way to get to the finishing line, which was also the beginning, was to make the tasks very, very small. I could be inspired by the big picture, the final leap, but getting there required a narrow focus, a new level of simplicity. I decided that I'd go slow, I'd feel it all—the nerves, the fear, the hope, the quickening heart, the tingle of possibility—and I'd take very conscious steps forward, even if they were tiny and tentative. This was an opportunity to exchange a good life for a simpler one, a braver one. One that felt true and right even if it was largely unknown.

So, I decided I'd bird by bird my way to our leaving day. Or, more literally, I'd take it odd sock by odd sock, keep it really simple, and resist getting overwhelmed by the length of the to-do list. Deciding this was easy, doing it was not. But I was reminded of the ancient Indian yogis who measure life in breaths and not days, and of the gentle reminder I often shared with my yoga students: *If you had to stay where you were for ten more breaths, what would you shift so you could be comfortable? What would you change if you had to stay here for a hundred more breaths, or a lifetime of breaths?* This was about getting comfortable in the discomfort of change. Settling into the upheaval and learning to live with uncertainty. I didn't realise it at the time, but this was preparation for nomadic living, which is, in its very essence, transient and

Let's bird by bird our way there

This was about
getting comfortable
in the
discomfort *of change.*

uncertain. And it proved that I am—and perhaps we all are—adaptable when we choose change, or when it comes charging into our life unexpectedly.

The change was big, but if you consider the months from start to finish, it was a series of decisions and tasks that flowed from one to another and were ticked off the list. This work started with a moment of intention. And in that moment I knew I had two options: I could stay in this fearful place of procrastination and avoidance or I could fling myself into the work and trust that we'd get to where we wanted to be. Trust didn't come naturally to me; I was well accustomed to catastrophising situations rather than sitting in the calm and steady waters of trust. But trust was what I chose, so that's what I ran with. And I repeated it like a mantra when I felt myself resisting the work, when I exploded into fear-induced tears, when I yelled at the ever-growing list. Mostly, I held on to the tingling edges of excitement before they dissipated into the overwhelm.

I was also aware that we had made the decision to downsize and live simply and that the work I was doing was necessary work. I had written about simplifying the home and living with the necessary for years on my own blog and others, and for some magazines, but now I was doing it item by item, shelf by shelf and asking: was it useful, purposeful, practical? Did it still fit

and could it be mended? Would someone use this for parts or was it destined for landfill? Should we sell it or donate it? Gumtree or eBay? Treasure or trash? Granted, we didn't have an excess of anything, but we weren't staunch minimalists, either. We had practised simplicity in our own way: being considerate of what we purchased, opting for pre-loved before we bought new, mending clothes, storing boxes of hand-me-downs and planning meals to avoid food waste. We grew herbs in pots, sourced weekly organic fruit and vegetable boxes from a local small business, and regularly visited the library. Still, we had wardrobes of things that tugged at my heart and I wondered, on multiple occasions, if pontificating about the narrative of each item was a waste of time. I soon realised that it wasn't indulgent, but necessary; if I considered it when I purchased it, I should do the same when I let it go.

This was very mindful work that required me to handle every single thing we owned. I wasn't just working towards a simpler life, I was living it as I sorted and donated and reflected on what we had accrued. There's a misconception that simplicity equates to ease of living when, in fact, it requires perpetual awareness and the ability to make measured, considered decisions—every day. I realised early on in the piece that even the work of simple living is, well, simple. It's always slow and considered, always little by little. I found myself, on many occasions, standing in the middle of the room, not knowing what to do next. And in that struggle, which stretched out for months, I was forced to continually lasso my mind back to the moment and sort the house out, one shelf at a time. I was sorting our belongings and sorting our life out, too. Here was how we'd lived for the past decade, how we'd grown.

Let's bird by bird our way there

Practising Simplicity

The heirloom books and toys, photos and favourite things had been packed away first in the grandmas' wardrobes, safe from mould and mice and bad weather. There was a box of tiny baby clothes, and blankets, too, because despite my declaration that there would be no more babies, so many of my most precious memories remained on the milk-stained onesies I had gently folded and tucked away. Memories of hanging muslin wraps on the washing line, my heavily pregnant body weary, soft and breathless, my arms longing to hold my baby. Those wraps, sun-bleached and drying in the breeze, held so much possibility and hope—dreams realised, a life about to begin, the subsequent upheaval as we all navigated new family dynamics. And then, on the flipside, the newborn yet to unfurl, fresh and new, remnants of vernix behind the ears because we don't wash our babies for a week or two. Cotton and merino that soaked up all the spills: milk and tears. The tiny clothes that were merely cloth until the baby arrived, now the keepers of the sweetest, sleep-deprived memories. I have no purpose for them but I know when I return to those boxes I'll lift the muslin to my face and inhale, hopeful for a trailing newborn scent, that elusive smell that takes me right back to those first days and weeks of heady love and overwhelm, where we existed in a rhythm of sleeping, feeding and settling.

In our final week in the house, my last baby was crawling in the living room where I had wildly pulled the remaining items to be sorted and stood back to survey the scene. This was the toughest bit: the final push.

Despite the clearing out I'd done over the months before, there were still a lot of odd socks. Twenty-nine, in fact. I remember because my mum insisted on washing them, hopeful that their pairs would miraculously turn up somewhere. The kids were smuggling soft toys into the caravan. I didn't know what to do with our most practical household items: two IKEA footstools that were decorated in domesticity—Texta scribbles, chipped edges and spaghetti bolognese stains. Our looming deadline was merely days

away; our house was scheduled to be demolished, our caravan waiting to be towed, and four children basking in the chaos. If you've moved house you'll know what those final days feel like, when you regret not doing more sooner, when you pack miscellany in boxes and promise yourself you'll sort it out at the other end. But we didn't have that option. Before me were the dregs and detritus of living, the somewhat essential, the outgrown and discarded, the things that had been pushed under the bed and to the depths of the wardrobes, forgotten and somewhat lost. There were apple cores and three dead crickets, translucent cicada wings and a handful of semi-crushed shells—remnants of a summer chorus. There were half-read novels and teacups, bedsheets and soap bars, school supplies and drink bottles. This was the end of the list—which was still stuck to the wall—and looked like an old preschool craft project: a cacophony of lines, ticks, strike-throughs and frantic, last-minute additions.

I remember standing there on that last morning in the house and acknowledging the work it had taken to get to where I was. Still, there was a mountain of miscellany that needed to be sorted and cleared within eight hours. So, breath by breath, sock by sock, I whittled down the debris until there was only a pile of dirt and dust, scattered like ashes on the floorboards. This stage of the journey wasn't without tantrums, disagreements and sleepless nights. But, on that late winter afternoon, as we exhaled and hugged and closed the door for the final time, it felt almighty. I was ready to leap; it was time to cut free and hit the road, to live big in a tiny home and get grounded. There were no photos or goodbye tears, but we bid farewell to the old blokes next door who sat on their verandah drinking red wine and we drove out of our suburban street at dusk with a crying baby and three kids already asking if we were there yet.

Let's bird by bird our way there

Chapter 4

Grounded

For as long as I can remember, I've worried, about little things and big things and the little things that seemed really big. My knack for worrying grew with me, surpassed the worry dolls that were placed with good intentions under my pillow and eventually turned into panicky anxiety in my late teens. I know that worrying perpetuates bigger concerns, and that it's all too easy for me to get caught up in them until they loom and threaten and dictate my days.

Psychologist Gwendoline Smith calls these ruminations 'thought viruses' and says that 92 per cent of them are about past or pointless things that we cannot change. I agree, but I still get sucked in far more often than is necessary. On the flipside, I know what helps to break the cycle and sometimes it is as simple as stepping into nature and finding a bigger perspective; the expanse of land, sea and sky squashes my small concerns. But getting into nature isn't always easy or possible and despite knowing it's the best thing for me, I haven't always gone there to reprieve.

Like so many parents, generation after generation, I have encouraged my children to venture outside, to play in the garden and boost their immune systems with the tiny microbes of trees and dirt. To grow up in the natural world so they know it, love it and develop a lifelong affinity with it. We equate a wholesome childhood with sandy feet, dirt under fingernails and pants that have been torn while climbing trees. And then we grow up and grow old and find ourselves so distanced from the natural world that once cradled us.

This age-old picture of a wild and healthy childhood is important. It's the one we are nostalgic for, the one we want for our children, and the one we need to save. It's also the one we need to embrace as adults. We may be

weighed down by obligation and the mental load, disconnected and fretful, carrying the concerns of loved ones and the anxiety of a fractured world, but we also need to remember the joy of being in the ocean or standing under ancient trees. The natural world has a profound effect on us, and as countless studies continue to prove, we are calmer, happier and healthier when we connect with nature.

On the road, as we found our rhythm in a tiny home, we stopped watching the clock and started, instead, to follow the sun. As the days passed and I grew more settled, I realised that my own sense of disconnection was twofold: I didn't realise how disconnected I was from myself until I lived in a tiny home. I also didn't realise how disconnected I was from nature until I was forced to live among it, to live in it. Before we hit the road I had

envisioned us in the caravan squeezing past each other like commuters on a peak-hour train and while I softened that discomfort with visions of an ever-changing postcard view from the front door, I didn't realise that a natural consequence of a small floor space was that you gravitate outside for space and light and air. We slept, washed and occasionally cooked in the caravan but everything else happened outdoors, on the grass and the sand, under the big sky regardless of the weather or season.

It was here, on the dirt, in small country towns, outback roadhouses and national parks that I reacquainted myself with nature and settled into my body, for the first time in a long time. Getting to know the natural world hadn't made it onto the pros and cons list I'd mentally created on the nights that I tossed and turned and questioned the validity of a year-long road trip

with four children. But getting grounded and feeling settled in my body hadn't either; it was a process of unravelling and letting go, first of the sense of duty and obligation that I carried—as a woman and a mother—and then learning to be okay with unpredictability, embracing the vulnerability of living so close to the elements, learning to live with it and, eventually, learning to love it.

On the road, as time went by, I let nature draw me back to what mattered. There was nothing unique or brash about the process. It was slow and gentle and simply required me to tune in, listen to the song of the land and watch the light as it changed throughout the day and the year: stark white in winter, a mellow golden in summer. I ditched shoes as often as I could and instead walked barefoot on grass, dirt, sand and stone to let my feet feel all the new places. I learned to see the land with my body and not just my eyes.

It was slow and clunky at first but, three weeks in, when I was standing on a beach on the mid-New South Wales coast, in a town famous for its tropical paraphernalia, I consciously closed the hundreds of mental tabs that had been demanding my attention for years. Again, it wasn't my plan to shut down those nagging demands; it was more a natural consequence of life on the road and the new perspective I carried with me through the day, focused on each moment instead of planning for all those to come.

That evening, as the kids played at the mouth of the river, I started thinking about the list I needed to tick off before bedtime: the washing, the uniforms, the permission notes and the lunch boxes. Interspersed with school requirements were emails, dinner, dishes, toy clean-ups, bedtime stories and settling the baby. I started to wave to the kids, rounding them up to hurry them along, because things needed to be done and if we didn't get a move on, a mad rush was inevitable. But then it dawned on me: I didn't need to do those things anymore. For the time being, we'd chosen to leave schedules and

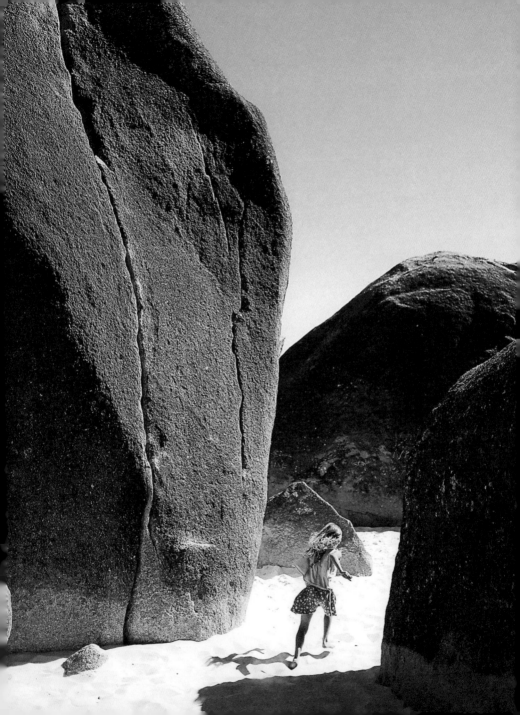

to-do lists behind. We'd consciously stepped off the conveyor belt and this was the consequence: no obligations, no school bells, no expectations. In that same moment I was very aware that sometime in the future those tabs would inevitably open again, so I consciously held myself in the moment, deeply feeling it all—the relief, the settling, the calm—so I could remember what it was like and, if need be, make my way back again, to the stillness of connection.

It's this same space that we crave when life feels too much and I've found it before on yoga mats, in the ocean, when I've gone to nature for a reset. It's there for you, too. Waiting, willing to settle your nerves and dim inconsequential worries. Perhaps when you find that thinking space, void of expectations and conversations, you'll do what I did and start pondering how to live. In that moment at the beach, while the children played and I sat very purposely in my stillness, I allowed myself to be open to the possibilities. I've always felt the pressure to make the right decisions, to make choices that seem good and worthwhile, but in that moment I recognised that with uncertainty and the unknown I was learning to live spontaneously, to trust in what would be.

With the closing of each day, I noticed a deeper sense of ease, and as I slowly learned to live with the dirt and grit of nature, I reflected on my relationship with it over the past decade. I may have spent my motherhood encouraging the kids to go outside ('Climb that tree!' 'Make mud pies!' 'Don't come in till dinnertime'), but I rarely gave myself the same advice. Despite my homebody inclinations, I knew the profound relief of walking on the sand and submerging myself in the sea. Often, when tension was high and arguments were brewing, when the children were bickering and nothing flowed, I would shepherd them out to that sweet spot where the ocean meets the sand. And then! The relief of that space: the wild sea that roared in winter and lapped the shore in the warmer months, the abundant rockpools where starfish sat

like jellies and rock shelves offered space for one child, the introvert, to draw on sandstone and collect walking sticks. Here, the bickering ceased and we all took big gulps of salt air to lift the lethargy that had made us all cranky in the first place.

Going to nature is always worth it, even if you don't leave home to connect with it. When I took the time to lie on the grass in my backyard, the washing on the Hills Hoist moving in time with the branches of the jacaranda tree, I let out a long and relieving exhalation. I know these things—sand, trees, salt spray, sky—get under my skin and help settle the nerves that vibrate just below the surface, because for as long as I can remember there's been a persistent hum in my body and a flicker of doubt in my mind. This was an anxiety I had learned to live with, one that ebbed and flowed with intensity and never really went away, and it peaked as we leapt into van life, so intense was the change, the fear and the uncertainty of what was to come. But often, the things we know we need, the things that are good for us, don't come easily, do they? And our own priorities can fall to the bottom of the list as we take care of everyone around us.

Sometimes,
we have no idea how far we've drifted
until we tune in to what's pulling us back.
Pulling us back to ourselves,
just the way we are.

Time and time again, it has been proven that nature is good for us. A view of trees outside hospital windows improves patient recovery times. Nature therapy is prescribed by medical professionals across the world to assist with a number of common ailments, from anxiety to high blood pressure. A recent study also suggests that it's the amount of time we spend in nature and the

depth of the immersion that matters. If I consider my life before we hit the road and the shifts that occurred afterwards, I would have to agree. I've lived both experiences and it's true: there is a difference between observing the natural world and getting into the grit of it—of submerging in the sea, walking so deep into bushland that it's only you and the trees, purposefully going to the quiet of nature and sitting in it, being with it, bathing in it. This is where the term *shinrin yoku*, or forest bathing, comes from—the notion of basking in the forest ecosystem, which pulses with energy and life, enveloping you in the quiet of its existence. Rooted in Japanese culture, it's a nature-immersion technique regarded as a sure way to improve health and vitality. In my experience, the age-old advice of fresh air and sunshine is apt after all; just add trees and ocean spray, river song and moors, and you have a concoction to treat worrisome ills and promote wellbeing.

On the road I learned, very quickly, that embracing nature was non-negotiable. We couldn't live in a tiny home and be separate from the wind and the sun, the sand and dirt. These elements were our home as much as the van was. And, living like this, we were so much more vulnerable to them; if it rained we had to bring everything inside regardless of the time of day or night. If it was windy the van would shake from side to side and the sound of each squall would punctuate our sleep. There was sand in every crevice, dirt in every fold of skin, and gumnuts and seashells lining shelves, pockets and steps. We carried it all with us and learned how to live with it. This was the reality of nomadic living, and it was a lesson quickly learned when we discovered our youngest eating duck poo on the fourth day in.

Practising Simplicity

Grounded

Living within nature, was, for me, a whole-body, sensory experience. In the past, I had spent time with nature, of course. I'd brought it inside at the turn of each season, grown herbs and kumquats in pots on the balcony, photographed the tiniest rain droplets that clung to spider webs, waited for the jacaranda to bloom in the backyard and dipped my toes in the ocean while the kids tumbled from the waves to the shore. I had observed and acknowledged it and admired it—from a distance. But I hadn't gotten among it until now. I had been living in my head, running through a very constant list of to-dos. So much so that I would forget, for days on end, to feel the breath moving in and out of my body and feel my feet on the earth. I treated nature more like an art gallery than an adventure trail.

On the road I became aware of the way I was in nature: standing, walking and observing, mostly. But then I watched my children and the way they instinctively immersed themselves in place; they sat in the dirt and rubbed it into their skin, they crouched on the sand and dug their hands into the wet, letting it fall through their fingers. They buried themselves in the dry sand as the sun beamed down on them, and they closed their eyes and all they could see was the white light. They climbed trees and clawed their way over rocks, they had dirt under their nails and leaves in their hair and as we journeyed deeper into the land they carried it all with them—on their skin and in their cells—infiltrating their minds to secure memories.

Is this something we lose as we grow, the natural inclination to sit on the land and immerse ourselves in it for fear of getting dirty, of being uncomfortable? And yet don't we romanticise the feeling of salt on our skin and the wind in our hair? Don't we equate those experiences with freedom, happiness, romance and awe? While I knew all this, it wasn't until I experienced it that I really got it. Because while I had found that stillness and quiet on the yoga mat many years before, this felt different. I felt settled for longer and, with my nerves still and quiet, I was able to be incredibly

present, noticing the details, tasting the air, experiencing a quiet in both body and mind. I slept deeply and without fretful dreams, my shoulders relaxed and I carried a sense of contentment with me through my days.

When you ground yourself in the natural world you allow yourself to be held. There's this part of you that surrenders to that experience, where you stop resisting and fall—physically and emotionally—onto the earth and into the sea. I had chosen to let go of all the sure structures in my life and do something that was so far from my comfort zone. But by stepping into my discomfort I also stepped into my courage, and from the very first day I started to learn a new way to live, because being in nature reminds me that I am part of the world. None of us are separate from the seasons or the elements and when we connect with nature and acknowledge its presence and power, we recognise that there is power in our own presence. It's an empowering and humbling realisation; you can't forget it once you know it.

Until I had that realisation, I hadn't noticed how much my disconnection had caused me to fret. I hadn't thought about how little I had walked barefoot on the dirt and the sand, or how often I walked on sure and steady pavements instead of the uneven surfaces of coastal rock shelves and bush tracks. There was a distinct flatness and predictability to my life, without the ebbs and troughs and physical challenges that made me move my body in a way that required me to focus on footsteps and breaths instead of dilemmas and catastrophes. I chose to lie on the couch or the bed instead of taking myself into the back garden where dappled light fell through the trees and onto my face. But, climbing the mountains on small islands, walking into the wind instead of cowering indoors away from it, taking off my shoes to feel the sand, the water, the shells; it helped me to reconnect. And it reminded me that my little worries—the ones that tend to accumulate quickly for me—dissipate when I step outside into the wild, where I am forced to connect with my feet as they step on the earth, sand and dirt, my energy and awareness brought down to the ground, away from the swirling worries in my head.

Grounded

Practising Simplicity

My connection to nature, my grounding, deepened the longer we lived on the road. The times when I was most settled, and felt a sense of ease and contentment, were when we lived without power and access to water, with minimal phone coverage, away from shops and traffic lights. Time slowed in those moments, because we did, too, and we had no choice but to tune in to the little things: how long we ran the tap for, if the solar panels were facing the sun, how much gas we used to cook and keep the fridge going, how much food we had and how I could stretch it so we didn't have to go out for more. We went without showers and washed in the ocean instead, and we wore the same clothes for days, which made me think that all those dirty clothes I'd washed over the years really weren't that dirty after all. Because when we were living with the essentials, narrowing our focus and, subsequently, our gratitude, to the simplest of things, we uncovered an undeniable joy. A joy so pure and simple and so glaringly obvious that we'd look to one another and nod in quiet agreement. Yes, this was worth the leap, this was worth it all, even if it is for a blip of time. We knew at the end of those days, when we fell into bed with a new kind of calm, that we'd never forget that feeling. Of not wanting anything but what we had in that moment, of being together and not having to be anywhere but where we were, in nature, where everything reminded us of our privilege and our purpose, of the choices we'd made and the leaps that got us there. But, mostly, these days reminded us that we can never underestimate the blessing of clear air and the rhythm of the wild ocean, the sky with cloud signatures and the stillness of dusk that begs for moments of reflection. I know that when I wander from this path that I'll come back to this time—in my mind, my heart— and remember my grounding, my perspective.

When we free-camped without power and with minimal distractions, we relished everything we were experiencing. We soaked in what we could see and smell, filing it away so we could return in our memories when we needed to come back to that feeling of contentment and calm. Those weeks on the ground, void of convenience but brimming with goodness, were some of the happiest of my life. And while I know that life cannot be an endless string of those experiences, I will always carry them with me. I know that, going forward, how we choose to live will ultimately be inspired by the simplicity we embraced there. Because that is where we learned to tune in to the minutiae of life, to breathe the air deeply, to dive into the cold ocean and embrace the jolt of shock and energy, to sit on the rocks in the quiet blanket of the dusk and be thankful for another day.

There is something distinctly primal about living like this and it makes sense, therefore, that we felt settled here, by shifting our focus to our needs instead of our wants. This is where we got really grounded, by focusing on our food, water and warmth, and filling our days with the essentials, the simple things. Living close to nature grounded me, but so too did our chores. Is there anything more ordinary than sweeping the floor, lighting the fire, hand-washing clothes and hanging them to dry, capturing the sun's energy and collecting rainwater? These were the essential jobs we did each day to ensure we could spend as much time as possible in the pockets of national parks and free camps. Here, in this raw simplicity, is where I was most grounded because I was required to focus on our most basic needs. When you focus on the necessary, the unnecessary slips away.

There was no restlessness in this outdoor mess where the kids shrieked and screamed, never having to quieten their voices, being as big and as loud and as wild as they wanted. This is where we climbed sand dunes and ran back down, where we washed in the ocean and let our feet turn numb in the creek that ran from the mountain, where we lit fires in the quiet of the night,

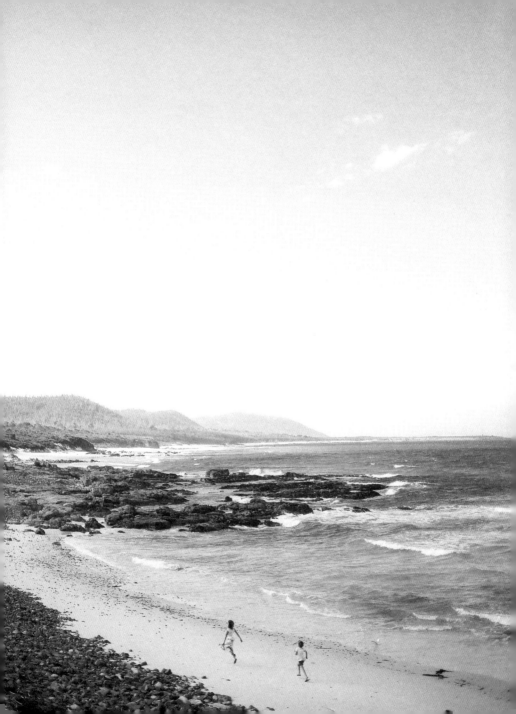

Practising Simplicity

captivated by the flames and the stars and the silence. We were a pack in the wild and I was learning to see the natural world as both a salve and a guide, somewhere to calm me and gently push me onto the next path.

Getting back to these basics allowed me to recalibrate. It was like we were starting again with a blank slate, where everything we were seeing and feeling was new and wonderful and worth pointing out to each other. We relished the restrictions of convenience and consumption and then, when we stepped back into normal life, we discovered a new-found appreciation for the little everyday things, like a hot shower! A freshly made coffee! Clean sheets! The sweet smell of a freshly bathed toddler!

I couldn't help but think of how plentiful our life was, but also, how unaware of my privilege I had been when I lived in the suburbs and turned the tap on without a thought about where the water was coming from and how much I was using. The privilege of our lives in this moment in time allows us to live distractedly and that naturally leads to a disconnection, from our food, water and heat sources, from our primal needs and, therefore, our grounding.

In nature I let go of the tethers to my old ways and learned to live differently. With bare feet and an open heart, I went outside to settle. Indeed, all the allegories of road trips—the freedom, the spontaneity, the adventure and the unknown—proved to be true. But underneath all of my experiences was a quieter, more profound truth: a simple life in nature is my grounding.

Chapter 5

Courage
and connection

You get a sense of Australia's wide brown land when you drive the Stuart Highway from Port Augusta in South Australia to the Red Centre in the Northern Territory. This north-south road stretches for close to 3000 kilometres and traverses some of the harshest environments in the country, where dry, dusty land meets the biggest, open skies.

We travelled it slowly, driving for hours in the morning and then stopping at roadhouses for the afternoon and evening. We'd ask the kids: 'What can you see to your left? Nothing! What can you see to your right? Nothing! What can you see in front of us? Nothing!' Because what we could see, for hundreds of kilometres, day after day, was barren earth and stark, clear sky. Nothing was really everything; it was the breathing space, the possibility, the sense of feeling so small and vulnerable and in awe of this iconic landscape that carried on, uninterrupted, to the horizon and beyond.

The further we drove, the redder the earth became. We started to carry it with us, in our hair and on our shoes. It tinged our skin like henna and marked our hearts with an atavistic knowing that this land is speaking to us; it deserves to be acknowledged and preserved. You learn to embrace the dust and dirt because it quickly becomes a part of you and you'll find it, months and years later, in the crevices of the car and the corners of your mind. This was the sunburnt Country of poetry and prose, sacred and mysterious, representing so much that we didn't know about our land and its ancient history. We made our way further inland and the wind grew wilder and colder, blowing all around us, whipping our hair and turning our hands scaly and dry. Once we crossed the border into the Northern Territory, the roadkill was prolific

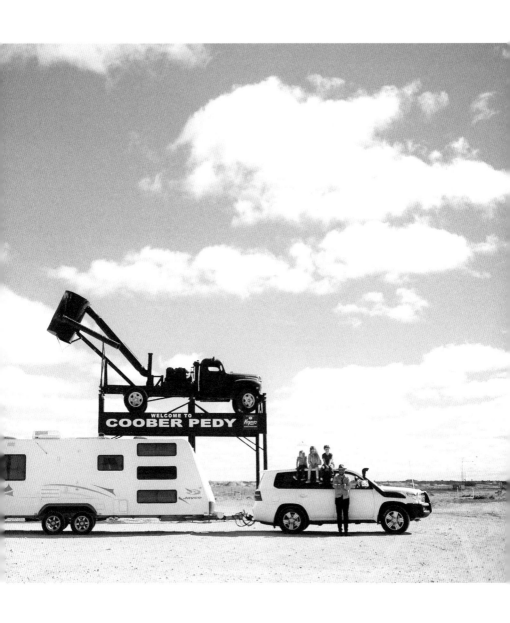

Courage and connection

and the mighty eagles that feasted on it stood proud and strong, unflinching, as we passed them.

We spent afternoons lying on rare patches of grass in the shade of even rarer gum trees, crunching those eucalyptus leaves in our hands, reading and drawing and chatting with other travellers. Come evening, when we sat outside the van eating dinner, tired bodies spooning food into our mouths, we discussed what we had seen and felt that day, we watched the sun set and let it turn us all golden.

We drove north for six days before we turned left and headed west to Uluru. Once we'd exhausted the snacks and sung to our road-trip playlist, we turned the music off and drove in silence, because it felt like this land deserved our quiet. Never before had we seen Country like this: vast and expansive, made up of the richest hues of dust and dirt that gradually shifted from deep peach, to rust, to ochre. We arrived late one afternoon with a convoy of travellers, many of whom were there to climb Uluru for the final time. It was six weeks until the climb closed for good and the people we spoke to were there to climb it, to say they'd done it, to do it one last time.

Indeed, it was a significant time for the Anangu people, the traditional owners of the land, and they politely asked all visitors not to climb, their plea spelled out on large signs throughout the national park. 'Uluru is sacred in our culture. It is a place of great knowledge. Under our traditional law

climbing is not permitted.' On another sign that explained the reasons behind closing the climb, the Anangu people posed a question that has stayed with me since I read it: 'Is this a place to conquer—or a place to connect with?'

I sat with that question for a long time, as the big kids ran ahead and the baby played in the dirt at my feet. And I couldn't help but think that regardless of where we are, we have a choice: we can either connect with the land or conquer it. Similarly, we can choose to conquer life or connect with it, awaken our senses, be aware of the light and the shadow, sit in our experiences and feel it all. It always comes back to choice, doesn't it? And that starts with being aware and simply caring about the way we live, and then, ultimately, creating a meaningful life—one that matters to us, one that we intentionally create for ourselves every day. We're currently living in a world where life is something to conquer.

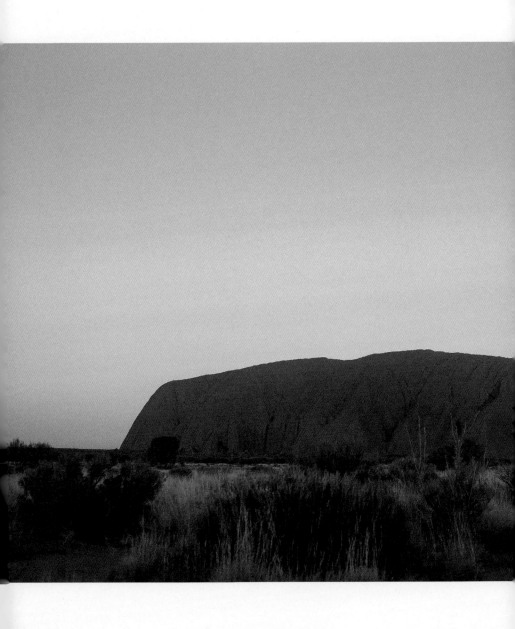

Practising Simplicity

We can choose to
conquer life or connect with it,
 awaken our senses, be aware
of the light and the shadow,
 sit in our experiences
 and *feel it all*.

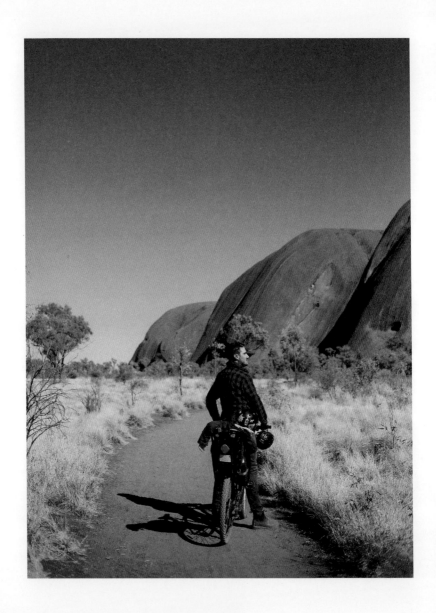

Practising Simplicity

We're encouraged to kick goals, compete, hustle and strive. But there is a desperate need for us to connect, to champion a simple lifestyle that consciously steps away from the rush and the race and finds contentment in a simpler existence—in our ordinary homes, in working less, consuming mindfully and connecting with our community to create, grow food, share ideas and advocate. One where we consciously step out of the conquering lane, take it down a few gears and cruise along, connecting.

We rode our bikes around Uluru early one morning, accompanied by a bitter desert wind that forced us into the moment, hyper aware of the way we pedalled on the dirt and the sand, the way we lifted our faces to the warm sun, the long, cold shadows cast by the rock. We weaved our way around, following the sandy path for 15 kilometres, stopping every hour to rest and talk. We were alone most of the time, yet despite the lack of people, the energy of the past was palpable. And it's that energy, combined with the striking majesty of the rock, which, if you let it, encourages a very deep contemplation. We are never truly alone in the natural world.

We returned every day afterwards, to just be there, in the red dirt, spending time. Here, at the base of Uluru, was a beauty unknown to me: a natural colour palette of sage and ochre, where the black trunks of desert oaks met the yellow wild grasses that softened the desert expanse. Uluru itself is mottled and marked, the waterfalls during the wet season leave long, river-like imprints, and traditional paintings tell stories of ceremony and culture.

We had never felt as small as we did there, and I have never known such humbling, because in the presence of such beauty and spirit, on the land of the oldest-known culture, was a new understanding of myself and the way I saw the world. It was here, at the heart of Australia, among the pale trunks of gums, as we ate cake, drank tea and cheered to our first year of travel, that I quietly acknowledged my own leap and the subsequent grounding.

We are never
truly alone
in the natural world.

I knew then the beauty and empowerment of fear because it had led me to this moment; I wouldn't have been there without it. I may have consciously chosen trust and then leaned into a new kind of courage along the way, but my fear of change and uncertainty is what had propelled me in the first place. I'd walked towards fear with enough trust and courage to carry me through. There was always a reason not to travel—many, in fact. Fear may have prohibited me in the past, but this time it had been the catalyst for change, a powerful forward force.

That said, I know I will never be free of fear. It is part of the human condition and we all feel it, in some measure, at some point in our lives. But before we left, as I purposefully chose to trust the choices I had made, I also knew that courage, as an act of love, stood opposite fear—softening and quieting it and, ultimately, creating space so I could move forward. Fear was my inhibitor; courage was my freedom. If I was going to be courageous enough to uproot my family and live on the road, I needed to practise courage every day before we left. Being courageous, behaving courageously, is something I pushed myself to do, even when I didn't want to do it.

Moving onward required me to move inward. I realised that courage helps us cope with fear so we can do the things that make life meaningful. I was actively and purposely choosing courage, just like I had chosen simplicity many years ago. It was not something to perfect or to achieve; it was, instead, something to guide me forward, something to come back to when I felt contradicted and doubtful. It was an attitude to embrace, even if I was doing so clumsily. I saw both courage and simplicity as a way to live in the world because, together, they allowed me to focus on what mattered, regardless of the unknown and the uncertain.

I was also aware that choosing to face my fear may have been courageous, but I was in no way experiencing suffering; I had not lost a limb, I was not facing a

terminal diagnosis, I was not travailing the depths of grief—I was healthy, I was privileged, I was well. I was also aware of this small pocket of time where opportunity presented itself. Was I going to take the opportunity and bring it to fruition? Did I value my privilege enough to make that leap, or was I going to let opportunity pass me by because I was also anxious, fearful and seemingly stuck? I was in control here. Again, choice.

Courage is not always heroic or brash; it can be a quiet and subtle strength found when we let go and surrender. We can't talk about courage in life if we do not talk about courage in birth and in death. And I can't tell my own story of courage if I don't also share the last weeks of my auntie's life.

Her cancer journey began the same week I discovered I was pregnant with my firstborn. Ten years later, with my fourth child in my arms, she was at the beginning of her end. I don't think it's a coincidence that the book that inspired our journey was a gift from my auntie, and that many of our last conversations revolved around our caravan, our road-trip plans and her advice for clearing a blocked pipe in the caravan kitchen sink.

In the last month of autumn, she migrated to her bed where she would spend the rest of her days and, when I visited, while the rest of the family talked in the kitchen, I snuggled in next to her and held her hand. 'I don't know what

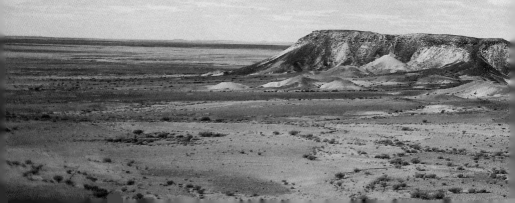

to do,' she said. The only thing I knew in that moment was surrender—a word I had taught hundreds of my pregnant yoga students and the word I had mentally repeated in the depths of my own labours, when I was between two worlds, digging deep for courage.

'I think all you need to do is surrender.' I felt her whole, small body soften and she exhaled and nodded. 'Yes.'

It was one of the greatest gifts of my life, to offer her that comforting word, the one that gave her permission to let go and, ultimately, be free. Surrendering was the most courageous thing she could do in that moment and she continued surrendering, for weeks afterwards, as we watched her body fade. On her final day we gathered beside her, as she travelled the in-between. The air was still and thick with anticipation and grief. We listened out for every breath, spoke quietly, and while this moment had been coming, we were still in awe that it was here, that we were saying goodbye, and that her life well lived was closing. There was the struggle, of course, the not wanting it to be happening and the simultaneous resolve that it was. But there she was, vulnerable yet valiant as she faced the inevitable, with an undeniable courage that is unforgettable. Her courage was in her surrender and it set her free, peacefully, gracefully and with ease.

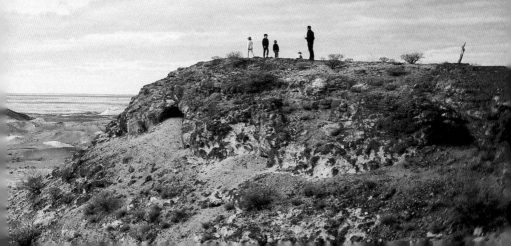

Witnessing her dying was one of the most defining experiences of my life, because how can we live fully, find happiness in the simple things and purposefully come into the present if we don't also hold in our minds the knowledge that life is fleeting, uncertain and dangerous? But if we shy away from the danger we would never climb trees, swim in the deep ocean or fly in a plane. We would never choose to uproot our lives and embrace unpredictability unless we believed it was a purposeful path forward. And I think, perhaps, when the fragility of life shows itself, we scramble to the sweetness of the present moment because we are reminded, with such confronting reality, that nothing is certain and the only thing we have is right now: this breath, this thought, this moment. Which begs the question: will you be fearful here, or do you choose to connect with your courage?

When magical moments happen in life and in nature, everyone stops and pays attention. As the sun sets opposite Uluru, there is a moment, a tiny moment in time where it illuminates, like someone has switched a light on inside it. It's like a real-life night-light. It actually glows and, just briefly, it feels like you do, too; the tingling sensations of awe and gratitude meld together and you feel otherworldly, like you're witnessing magic. You really do feel small and insignificant when you observe such unfathomable beauty. But I noticed, as the crowd dispersed and I started gathering up children and lunch boxes, that alongside this sense of being inconsequential was a very distinct sorrow: that this beauty is fleeting and that we aren't doing enough to save it. Can this awe and sadness exist together, and is this what will propel us to make lasting change? Will this inspire us to connect instead of conquer? To channel our courage and quell our fear?

Chapter 6

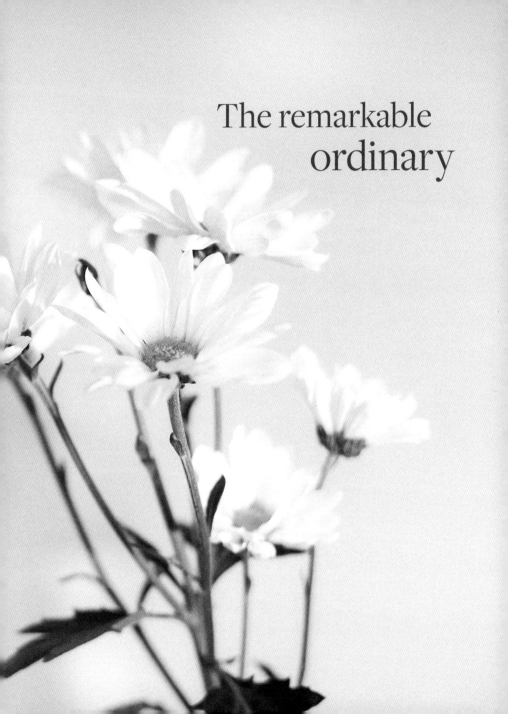

The remarkable
ordinary

Years ago, when the children were small and there were only two of them, we would talk about our best and worst parts of the day at dinnertime. Gathered around our timber dining table, a candle burning, night falling, we started a tradition that has since become a daily ritual. We would ask the kids: what was your favourite part of the day? And then, what was your least favourite part of the day? Or, as someone would often pipe up: 'What did you love and hate about today? Your turn first!'

What we continually found was that the things that irked us seemed inconsequential when we sat them next to our blessings. And, by taking the time to remember and recall them, we were able to savour them for longer and share them with each other. Problems halved, joys doubled, et cetera.

I made a point of continuing this tradition because as simple as it was, it had the power to shift my perspective, which was so often caught up in the work and exhaustion of raising small children. By dinnertime, I was usually counting down to the moment when silence descended on the house, and while I don't necessarily consider that a bad thing (early motherhood is relentlessly demanding, after all), I realised that dinnertime and conversation offered an opportunity for pause and reflection. We came together, to ground ourselves with a homemade meal and share our gratitude. Without it, I would have gone to bed clouded by small troubles.

As our family grew, so too did our conversations. We continued this tradition as we travelled and what became obvious to me was, regardless of what we had seen and where we had been, the kids were grateful for the simplest moments and things: puddles, ice blocks, playing with new friends at the park. Even today, if you ask them about their favourite experiences, the moments that

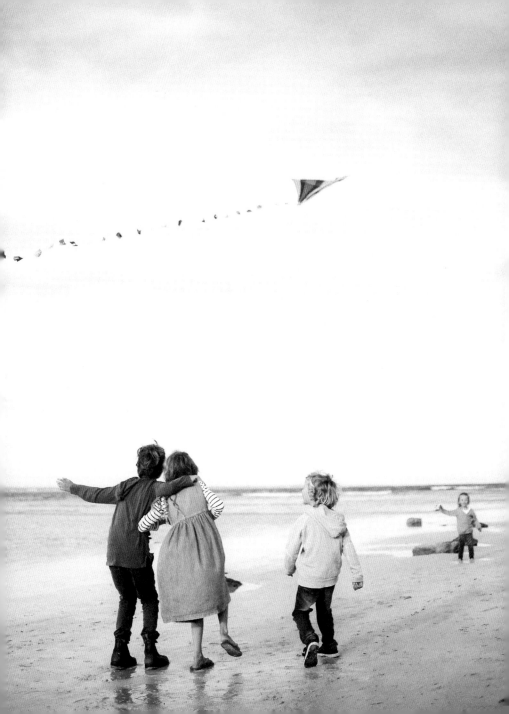

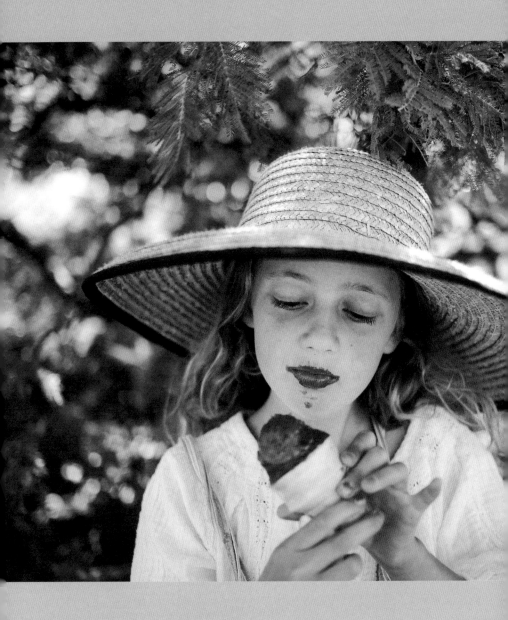

Practising Simplicity

were really unforgettable, they'll recall—with a dazed, glad look upon their faces—the ginger beer they drank in Bundaberg, the gelato they shared with friends in Melbourne and the s'mores we toasted over a fire in outback South Australia, a black sky dotted with stars above us, a herd of inquisitive sheep nearby. Perhaps they are most buoyed by sugar or they simply believe, with all of their being, that food is an unforgettable pleasure worth savouring, dreaming about, reflecting on, pining for.

I have written about the simple joys for over a decade now, in part to remind myself of the beauty that exists in my life and also to stay grounded in the social-media industry, which is fuelled by unboxing and big reveals. It can often feel like a risk to write about the smaller stuff: the unfinished, the normal, the gritty patina of a messy life without filters and flash. But I believe we are enough as we are. Even in a state of flux we can still sit in gratitude for all that we have. Even though the world is out to tempt us with all that is shiny and new, I'm happy to stay in the simplicity of what I've already got. We are all a work in progress and sitting in gratitude, for life just as it is, and knowing it's enough, is my daily reminder.

While we travelled, ate ice cream and embarked on beachcombing adventures, there was one experience that stood in stark contrast to the frivolity of our afternoons by the sea. We were only two weeks into our trip when we noticed that the car was using an excessive amount of oil whenever we towed the caravan. We had purchased what was regarded as the most reliable four-wheel drive on the market, and spent a significant amount of money on it because it ticked all three of our boxes: it had the towing capacity

required for our caravan, it had seven seats and it had airbags for every passenger. It was exactly what we needed for safety and practicality. Just three months into the trip, we discovered that we would need to source a new engine or refurbish the existing one. Multiple mechanics diagnosed the same issue and the reality of what lay ahead of us was bleak: it would cost us anywhere between twenty and thirty thousand dollars to fix.

There were so many moments when this issue dictated our days, whole weeks sorting through the options, making decisions, emailing the unhelpful car dealer and seeking opinions from experts. We broke down multiple times in all manner of places and, on one particularly stressful day, we had to reverse down a steep hill in Tasmania with the caravan attached (not an experience I would recommend). Eventually we spent ten weeks in the outer suburbs of Melbourne waiting for the engine to be refurbished. When we paid for it, there was no money left in our bank account. We knew we could live frugally on the road and trusted that my freelance work would keep coming, but still, there were times when I wondered and worried.

It felt so big at the time, so unfair. Deep down, I knew it was merely a problem we needed to deal with, but it was challenging to be in this situation so soon after hitting the road. All that work to get going and we had already stalled. I threw my tantrums and cried about our bad luck, but of course there is always perspective in these moments, if we seek them out. I chose to focus on the fact that we were lucky enough to have the money to pay for it and not the fact that it took all our money to do so. I also knew that we had options; it would mean living very, very consciously for the months to come, but that was okay. We'd only buy food and diesel and caravan park fees when we could afford it. At dinner every night, tucked around the table in the caravan because we were in deep autumn and the sun set early, we continued to weigh up our gratitude and our misfortunes, focusing on the good even though the unfortunate seemed all encompassing.

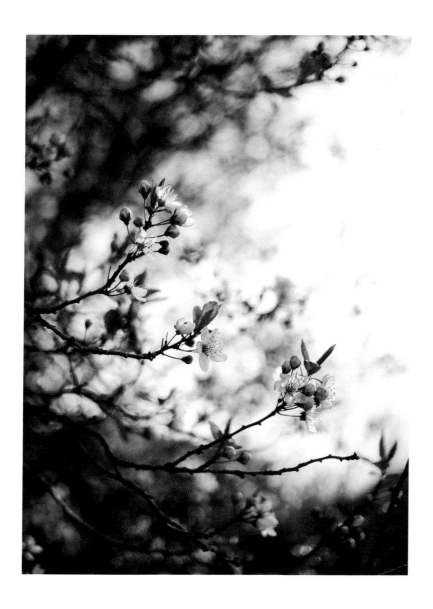

The remarkable ordinary

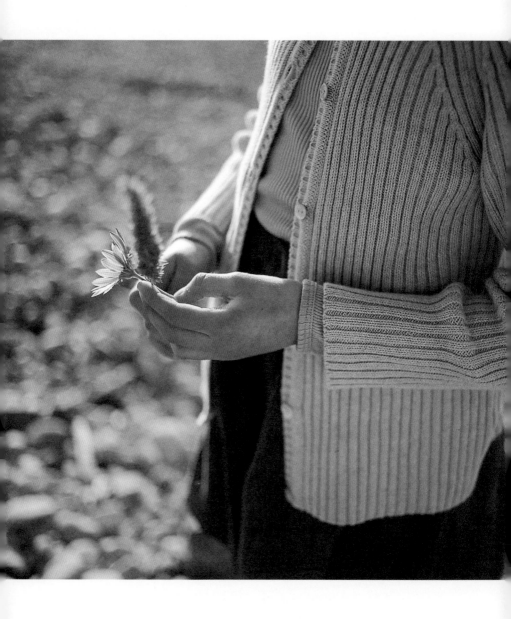

Practising Simplicity

In the most ordinary times of discomfort, bad luck and unexpected change, it's hard to find the remarkable. You have to purposely seek it out, which is never easy, nor does it come naturally for most of us. But it's there. And I find that when night comes and I'm asked about the best parts of the day, it is the simplest things I focus on—a really good cup of coffee, a riveting book with many more chapters to come, a walk around the neighbourhood to collect autumn leaves, drinking hot chocolate while snuggling up to watch an afternoon movie, a new jumper found for a steal at the op shop, an extra-long hug. I'm never not charmed by the fact that it is the everyday, ordinary things that bring the most comfort and connection in bleak times.

It's true of reminiscing, too. You may find it incomprehensible that when I think about our trip, I don't immediately recall the car troubles. In fact, when I reflect on all we experienced, the cost, the stress and the deliberation don't come to mind. They are dwarfed by the moments of awe, the togetherness, the paths we walked and the songs we sung as we drove to new places, the meals we shared at the end of long travel days and the water we swam in—the slow and simple life we chose for ourselves, despite the inevitable hurdles.

Perhaps I wouldn't have the deep gratitude for the opportunity to travel, for the desert red or the canola fields, the tea-tree lake or the kite flying if we hadn't first pulled our way through the mental and financial exhaustion of fixing the car. Again, it is just life, isn't it, which is always complex and contradictory. I do wonder if we can experience the breadth of happiness if we don't also know disappointment. Would we even know to savour the good if we didn't first experience the bad?

This simple attitude—of accepting things as they are and being grateful for what we have—reminds me of *wabi sabi*, the ancient Japanese philosophy rooted in Zen Buddhism.

To very purposefully sit in a moment of contentment and know that it is fleeting is the very essence of *wabi sabi*. Within the pages of Japan's most highly regarded dictionary there is no mention of it, yet it is understood as a way of life: a feeling, an instinct, an intangible directive that is intimately entwined with nature and the nature of life itself—transient, imperfect, beautiful. The word *wabi* translates as poverty. It encourages a balance between the pleasure we find in material things—the stuff we seek and accrue—and the pleasure in finding freedom from these things. *Sabi* acknowledges the simple reality that nothing lasts, nothing is finished and nothing is perfect.

In essence, *wabi sabi* is the beauty of change and impermanence, which is not separate from the disappointment and chaos of life. It encourages us to see the light in our flaws and, regardless of our faults, to move on, accepting them, embracing them, even celebrating them. It's the remarkable ordinary and, for me, it's knowing that a slow, simple life feels good and is, therefore, enough. I've found that this simple attitude—of finding beauty in the flawed and ordinary and not spending money on things I don't need—has helped me to sit in the contentment of the present moment, however fleeting, and be grateful for what I have instead of pining for what I don't.

Of course, sitting in the contentment of a simple life is not always easy, nor is it always possible. We will often be challenged by the choices we make, especially if they aren't the norm. It happened regularly as we travelled, when people would question our decision to sell everything we owned and spend all our money so we could live in a tiny home on the road. They weren't being judgemental, but rather inquisitive about the life we had chosen.

Practising Simplicity

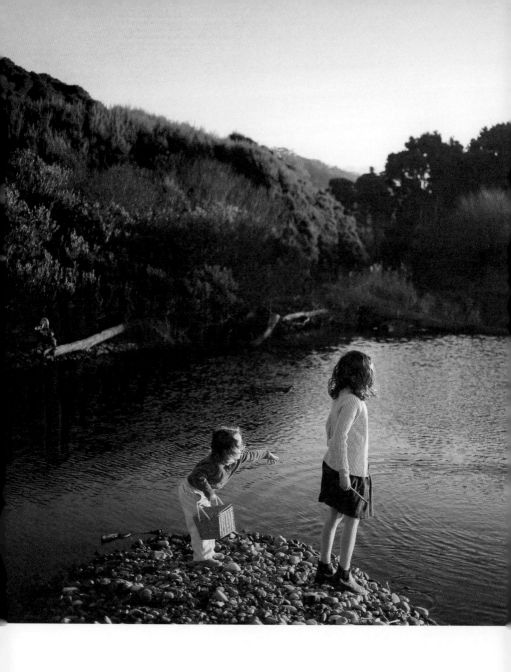

Practising Simplicity

I'm never not charmed
by the fact that it is the everyday,
ordinary things
that bring the most
comfort and connection.

And that's just it: if we have choice in the first place then we need to recognise the privilege of that and accept that the decisions we make for ourselves aren't always going to be understood or appreciated by those on a different path. And I have had my doubts. I often wonder if perhaps we should have bought a house years ago, created solid roots for our family, stayed with the familiarity and predictability of life there. These thoughts flooded my mind when people we met questioned our choices: 'Don't you worry about your future?' And, while we explained our lifestyle, the leaps we'd taken and the sacrifices we'd made, most couldn't get their heads around the uncertainty of what we had chosen. I wholeheartedly understood where they were coming from because I'd asked myself the same questions every day before we hit the road. I'd been conditioned to think that success was a stable career and a mortgage, and stepping off that path to explore a different way was filled with fear and doubt, even if, deep down, it felt right.

Some days I still have to very consciously come back to the crux of my beliefs when I feel myself competing with those who have more, when I am consumed with wanting what I currently don't have. I remind myself of the choices I've made and trust in the experiences I've had because I know that I am content in choosing less and seeing more, in cultivating delight in the simple things and seeking solace in nature. As someone who always felt the definite tug to finish things, I've had to learn to be okay with what is: the slow journey from now to the next moment, working my way through the transitions of life much like I did in birth—the uncomfortable, challenging, confronting stages that require patience and trust. And then to very purposefully sit in a contented pause and simultaneously realise that it is fleeting. I think this naturally leads to the acceptance and appreciation of the impermanence of all things—ourselves included.

I have to bring myself back here often when I start to feel that pressure to compete. So, what brings me back? The peril of the natural world, the havoc

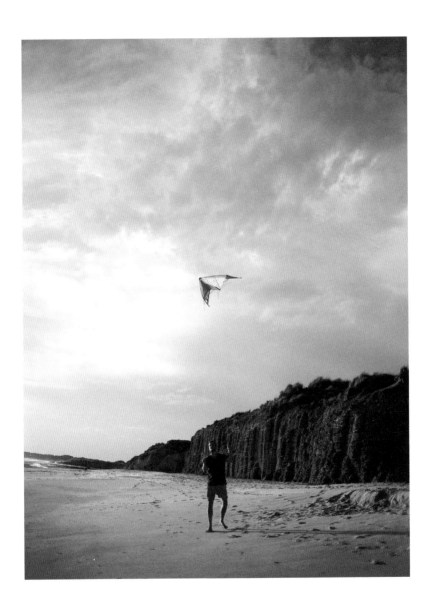

Are you ready to be delighted by
the glorious monotony of the everyday,
to celebrate the *remarkable ordinariness*
of life and yourself?

we collectively wreak, the blatant disregard for the racial prejudice that persists in our communities and the support of the wealthy while the poor continue, silenced in their struggle. Never before have we had instant access to so many stories, to be able to listen to the voices of those who speak up and not turn our heads when what we hear is confronting. To pay attention, to read and learn and keep sharing the wonderful and brutal things we come across. To keep looking for the good and then look at our own lives ... and know that we are enough.

In nature I'm reminded that no one's rushing things along. And I know that when I'm not distracted, I'm able to consciously slow down and restrain myself from rushing. When I take the time to choose a cup, pour the tea, sit facing the sun, peg the washing and stand back to watch it catch the breeze, I notice these things are simple and beautiful parts of my day that are always there, even when I can't find gratitude for them. There is grace and beauty in the slow and the subtle, as there is in the ordinary. And perhaps that looks like digging the earth with your bare hands to uncover the potatoes that grow underground, or threading cotton over and under to sew a patch. Maybe it's knitting a blanket and listening only to the clink of the needles as they move, or stirring risotto over and over again, knowing that there is no way to hurry up the cooking; time is necessary. The same goes for the rising dough, the germinating seeds and the incoming tide. It's these marvellous little happenings that we easily walk past, yet when we pay attention they disarm us with their delight. Which begs the question: are you ready to be delighted by the glorious monotony of the everyday, to celebrate the remarkable ordinariness of life and yourself?

Despite the ongoing upheaval of the world, there is something undeniably soothing about the simple things that make up our days, the things we can rely on and find comfort in no matter what may be happening outside our windows and on our screens. It might be the first sip of coffee, the sun tumbling through the kitchen window as you stir porridge, the crackling of

the fire in the depths of winter, the dulcet tones of the classical-music radio host, crawling into fresh sheets, a generous spread of butter on fresh sourdough, slurping chicken soup and diving into water so cold it makes you gasp. It is this simplicity that opens our eyes to contentment; being grateful for these things is learning to acknowledge the remarkable ordinary that exists all around us. We see it when we slow down, come into the moment and pay attention.

Whenever we were driving, whether we were on a day trip or towing the van to a new destination, I would interrupt conversations and sometimes wake the baby when I pointed out the beauty of the landscape we were passing. I'm sure that, in years to come, when the children are grown and they've returned home for dinner or to do their laundry, someone will bring up the road trip and they'll lovingly roll their eyes as they recall the way I enthusiastically exclaimed at the trees and the light and the long, yellow grass as whole hills of it danced in the wind. You see, I pay attention to these things because they matter, because they genuinely stir a deep contentment within me, and I point them out to the kids so that they learn reverence for these simple things, so they can see, feel, touch, taste, witness and experience the natural world, the good that is all around them, in their own lives.

When I stopped seeking the perfect I learned to bask in the present. I never set out to discover this about life, but that is the wonder of unintended consequences: when you slow down long enough to pay attention, you realise that there really is good all around.

The remarkable ordinary

Chapter 7

On owning less

(which is still more than enough)

I'm not here to nag you and tell you that you need to live with less stuff. Nor will I tell you that owning less is a sure and certain path to happiness. But let me tell you what it's like to carry all you own with you, to choose those items with care, considering their purpose, size and weight, to reduce your consumption and increase your free time and to realise that everything you need in life can fit in a caravan along with those you love most—for me that was one grown man and four growing children.

If you had asked me to holiday in a caravan four years ago, I would have baulked at the suggestion. Daniel suggested it one day while I lugged the washing from the line to the lounge and I bellowed down the hallway: 'A road trip in a caravan is not a holiday!' At the time, I couldn't think of anything worse than squashing my family into a van and attempting to make dinner on a tiny bench space before having to wash the dishes in a sink fit for three bowls. But because time and perspective and choice and change are all wonderful things, I came to see the tiny space of a van as an opportunity instead of a hindrance. There was work involved—as there is in life, no matter where or how we live—but I started to consider the boundaries as an experiment in learning to live with less. Here was my opportunity to significantly downsize, live with no fixed address and only the essentials. Everything had to earn its keep although, I admit, the ephemeral items—the kids' craft and nature collections found on empty beaches and desert paths—joined us, too.

While I don't expect you to live in quite the same snail-like fashion that I have for the past few years, you may like to consider the concept of breathing space and thinking space: the space free of stuff and clutter, in your house and in your mind. Because when there's less stuff to take care of you have

more time and you realise that the things you accrue sometimes aren't worth the hours you spent working to pay for them. Weighing up frivolous consumption and precious time is a really tangible way to practise simplicity and it can, if you let it, shift the way you see the world and influence how you live. You start asking yourself: what do I value—time or things? And I find this question naturally leads to ruminations on the sheer amount of stuff that already exists in the world and the blatant fact that we are consuming more than at any other time in history, to the detriment of the natural world and its resources.

It's really easy to be confronted and silenced by the reality of a world in crisis and our responsibility for it. But if you believe that your choices matter, and that they can be a catalyst for change, you'll be spurred to stay on a path of living with less and find it's actually quite rewarding. I'd even go as far as saying it's life-affirming.

For me, it started with the dishes. When we were living in a house and navigating life with three children and a newborn, I spent many evenings cursing the mountain of dishes on my kitchen bench. I loathed them with such passion that no attempts at mindfulness could relieve my frustration. I'm sure a dishwasher would have helped, alas we were living in a rental and no amount of kindly worded emails would convince the owners to install one. Daniel regularly worked late and I, having just put the children to bed with stories and back rubs and milk, would trudge down the hallway and muster the energy to deal with the towers of plates and cups, lunch boxes and snack bowls, pots and pans. I knew it would take me over an hour to get through them, even longer if the baby woke. I cursed myself

This is frugal abundance;
working less to live simply,
instead of working
to buy things we didn't need.

Practising Simplicity

multiple times for not rinsing the bowls that now had hard porridge caked to the side, unbudging—the kind that needs a good soak and the patience of anyone other than a bedraggled mother at 9 pm.

We had an entire kitchen full of cutlery and crockery, teacups and pots, kids' segregated plates and Tupperware containers with too many lids. But, in the van, we survived with one frying pan and two saucepans, a bowl and a plate for each of us, a few cups and ample cutlery. We washed the dishes in our tiny sink and towelled them dry, and not once did we feel like we needed any more. And if something broke? We just popped into the local op shop to replace it.

This new simplicity, of cups and cutlery, was life-changing. It freed up time and space and relinquished the dread of those evenings spent with my hands in the suds. (I also passed on the morning and evening dishes routine to my two eldest children, which was met with a year's worth of whinging, but is now an accepted part of their day.)

I'm realistic; I know that regardless of where we live and what is happening in our lives, there will always be dishes. As the Zen Buddhist proverb goes: 'Before enlightenment, chop wood, carry water. After enlightenment, chop wood, carry water.' But I'm in control of how many dishes we own and if we can eat three homemade meals a day and get by on the basics then it's hard to ignore the maths. It turns out that simplicity is also about restraint, which I believe is a discipline worth celebrating—one that allows you to say no, cherish your belongings and avoid the excess: stuff, and decisions. Living with less isn't just about the things we accrue and keep. It's also about having fewer expectations and less pressure, less work and debt, less to clean and less to sort. And although you may live with less, you end up with so much more.

On the road, during the weeks that we were most frugal and filthy, and especially when we free-camped and lived remotely, we agreed that we'd

never had it so good. I was continually fascinated by the fact that we were so content in a tiny home with only the essentials (times six, that is). We had packed our necessities: clothes, shoes, wet-weather gear, towels, toiletries, a medicine kit, kitchen basics, a beach umbrella, a few toys, stationery supplies and a rotating collection of books that we would swap at street libraries and caravan park laundries. It was everything and enough, and perhaps most pertinent of all: we didn't want for anything else. As the weeks and months passed, I reflected, quite regularly, on the significant shifts we'd made and how different I felt with so little to take care of. And this is the very crux of living with less, for me. When we lived in a house, with full cupboards, albeit full of consciously sourced, beautiful items that I loved, I still thought about them when the doors were closed. They may have been invisible to everyone else but I felt their presence and their weight, the pressure to take care of them, sort them every now and then, deliberate on whether or not they were still necessary in our life. They may have been lovely and useful, they may have filled a void, but despite all this they were still a contributor to my mental load. I may have carried everything we owned with us on the road but I didn't feel the weight of it all because everything had a purpose; the little things and the big things all earned their keep.

While the life-changing shifts may have started with the dishes, they really became profound when I realised that without the need or desire to accrue, we didn't have to spend time working for things. We had simplified our home and our essentials to such a degree that we'd freed up time. This is frugal abundance: working less to live simply, instead of working to buy things we didn't need. And while I'd read so many books over the years,

no amount of reading could have prepared me for the experience of living in a tiny home on wheels and sitting in the simplicity of it. Living with less gave me more time, space, energy and money. I had fewer obligations and more opportunities. I felt lighter. And so much happier. As Daniel remarked to me a few weeks into our trip: 'We've just got to create our own opportunities for happiness.'

We may connect materialism with excess consumerism, but living with less actually prompts you to care more for your material possessions, to really cherish what you have. I've learned to be reverential with my belongings, to connect the purchasing of new things with the hours spent working for them and considering if there's value there. And then, thinking deeply about where the product comes from, what it's made of and who made it. If simplicity is about focus and intention, then you can approach consumerism in exactly the same way. And ask yourself: why am I buying this? What is its purpose? What do I intend to do with it? Can I source it second-hand? Is it something that will transcend seasons and time? Of course, it's more complex with children, and perhaps even more so as they grow, but teaching them the virtues of patience, restraint and gratitude seems particularly important in this age of disposability and consumerism.

So how do you decide what to keep and what to let go of? It's complex and, in my experience with four children, it's ever-changing. I rest in the knowledge that it will never be finished, that there will always be some level of order but, frankly, there are always going to be odd socks. For as long as we are a family, living in a house and going to school and creating and growing and learning, there will be the miscellany that comes along with life: the keys, the drawings, the washing pile and the apple cores (inevitably prolific in autumn). Letting go of the minimalist aesthetic of clean lines and finished projects is a really practical way to accept that, often, our simple lives are a little messy and rough around the edges.

Simple living is like a ramshackle garden:
it ebbs and flows with the demands of life
and its seasons, ordered and bountiful at times,
a wild, uncontrollable meadow at others.

Simplicity is not concerned with perfectionism or, in fact, staunch minimalism. It's more authentic than that. It's growing a garden and letting it go to weeds when life gets too demanding to tend to your plants. It's reminding yourself, as you get closer to Christmas, that you have bought enough and the last scramble to fill stockings and please those around you is, in fact, a figment of your ideals and not at all necessary. It's buying your food in bulk to reduce your plastic consumption but then finding yourself with packets of two-minute noodles in your cupboard because, all of a sudden, you're the parent of a teenager and that is a hunger no amount of meal planning can satiate. At the crux of simple living is the intention to live authentically and embrace the failures and successes of it all. Simple living is like a ramshackle garden: it ebbs and flows with the demands of life and its seasons, ordered and bountiful at times, a wild, uncontrollable meadow at others.

Living with less changed my life because it proved to me that there's an undeniable freedom in living unencumbered by the things I own. There is also time and energy and creative thinking space when I don't shop or hunt down or work to pay for the things I don't need. And when I do peruse and buy in a bookshop or finally buy the woollen knit I've been saving for, I wholly revel in the opportunity to purchase something beautiful and practical that I love and know I'll cherish and will take the time and energy to mend when, in years to come, I snag an elbow on a fence post or a tree branch.

And that's not to say that you can't have the ephemeral and the impractical. Often, the most frivolous items we own are the ones that mean the most to us, like the string of bells that we have near the door of the caravan. They don't even really jingle but we've hung them in every house we've lived in and they're a symbol of our togetherness, of how far we've come. The van is also decorated with bunches of gumnuts and collections of seashells, prized rocks and mighty walking sticks. We carry these things because they're part of our story, of where we've been and how it's changed us.

Whenever I reflect on our experience on the road, I come to the conclusion that you really don't need a lot to live well. And as I sit with this idea, there is the inevitable next question: what exactly do I need to live well? What are my non-negotiables for a good, contented life? What do I choose to cherish and what do I choose to let go of? And what I've realised is that it's not necessarily 'things' that I need, but a detachment from them. I can find joy in a beautiful teacup, a skirt with pockets and a bookshelf full of novels, but a good, contented life does not stem from belongings. It comes from freedom from them.

These are questions you can ask yourself, too. They don't need to be answered right away. In fact, they're the kind of questions that you'll find yourself mulling over, wondering what if and maybe, considering in moments of contemplation when you're faced with a mountain of dishes, the bright lights of a busy shopping centre, or the dread of yet another week of rushing backward and forward while trying to catch your breath.

What are you willing to sacrifice for time—in nature, in thinking space, with those you love? Because if life really is uncertain, then all we have is now, this very moment—time. And if we don't value it and cherish it and use it wisely, in ways that fill our heart and soul, making memories that we'll reflect on—of love and beauty and courage and awe—then what are we doing?

As with all aspects of simple, slow living, it is layered and evolving and there is no step-by-step guide that will see you living with less in a quick and

efficient fashion. Indeed, this isn't about a quick fix but about choices that are considered and informed and ongoing: the ones that will inevitably become new perspectives and attitudes, that take time and patience and practice to form and take hold.

Simplicity does require energy and awareness, as does sustainable, ethical, waste-free, frugal living. You have to constantly check yourself, observe your spending habits, consider the implications of your purchases and figure out the best way to stretch the leftovers in the fridge. Of course, there are times and seasons when the complexity of life is both confronting and challenging, and you realise that the simplest thing you can do is surrender to the ease of convenience for weeks and maybe months. Because regardless of how much you care about the earth, how passionate you are about using less plastic and buying local, sometimes it's just about doing what you have to do to protect your wellbeing. Living with less, in these instances, means less rules and expectations and surrendering to the ease of convenience, a kind and compassionate simplicity that feels achievable.

It's in these hard times, and also the good ones, that surrounding yourself with like-minded people can bolster your own simple-living journey. On our second Christmas Day in Tasmania, when we were still living and travelling in the van, we gathered with new friends, all of whom had migrated from the mainland. And as I stood in the kitchen, washing dishes while meals were prepared and, later, separating the compost scraps from the meat remnants, we started talking about whether to throw the meat in the rubbish bin or send

Practising Simplicity

it home with one of the guests who lived in an area where the council provides a FOGO (Food Organics and Garden Organics) bin collection on a fortnightly rotation (and a significantly smaller general rubbish bin to deter households from lumping all their waste into it). Granted, it was Christmas Day and there were seventeen of us full from a decadent lunch, a few of us busy preparing desserts, kids running excitedly through the house and into the garden, lots of chatter and cheer. There were a lot of leftovers carefully packed away to be used later and, understandably, a lot of scraps. But if it doesn't matter in these instances, when the food and the scraps are in abundance, and there are many hands to help, then when does it matter? And while you may be thinking that it's perhaps a little strange to be buoyed by such a conversation and to feel a sense of belonging over kitchen scraps, I understand. But this is the stuff that matters, these are the things that unite us and there is a beautiful contentment in finding people who are passionate about the same things that you are.

In his book *The Art of Belonging*, Hugh Mackay says, 'It's not where you live, it's how you live.' Indeed, discover what makes you happy, do the things that feel good and right, talk about them—in the grocery store, with your friends, to your neighbours—and, chances are, you'll find like-minded folk close by, on a similar path, willing to teach, listen and share. As particularly social creatures, we are hardwired to seek a sense of belonging; it is, in fact, one of our primary needs. And whether we find it online or in our neighbourhood, connecting over books we love or food we grow (and later compost), finding your community and learning from it is a really powerful step forward. Yes, simplicity is something you can practise in solitude, but investing your time and energy in the collective good really bolsters your lived experience and propels you to stay the meaningful course you've chosen for yourself. This is the path of change, and while it may start with you asking questions and making decisions based on how you want to live in the world, it's the ripples that are really effective. Living with less is a wonderful way to live, but sharing the journey with others does sweeten the experience.

Chapter 8

A life
less distracted

Right now, as you read these words, you may be thinking about the demands of your hurried life and the little space you have for quiet and stillness. Perhaps you are considering how many times you reach for your phone each day, the lists that run around in your head, the constant chatter of the people you live or work with, or the hyperconnected world we live in that so boldly demands our attention and our productivity. But what if you regard your attention as a precious resource, one that should be given with care and awareness? What if you reminded yourself that you have a choice?

When I meet people who want to know more about why we packed up our lives and travelled in a caravan, I tell them that I grew tired of the rush and the race, of always feeling like I needed to hurry, of living switched on and, subsequently, wired. I was permanently distracted and perpetually exhausted. But if I dig down to the crux of my distraction, I can see that I was running from my discomfort; I was consuming too much, rushing too often and living a life that just didn't feel right. The rumblings of change were disconcerting, so I distracted myself until I could no longer ignore them.

We are living in a time of unprecedented distraction and it's never been easier to run from ourselves. And that is exactly what we are doing, in a multitude of ways. We are more connected than we've ever been but, ironically, lonelier. We are expected to pay attention 24/7, to be switched on and available, and instead of backing off and venturing into a form of restful quiet, perhaps even intentional laziness, we distract ourselves with more scrolling, stepping further and further away from what we most desire and what we most need. By distracting ourselves from our nerves, we continue to feed the fret.

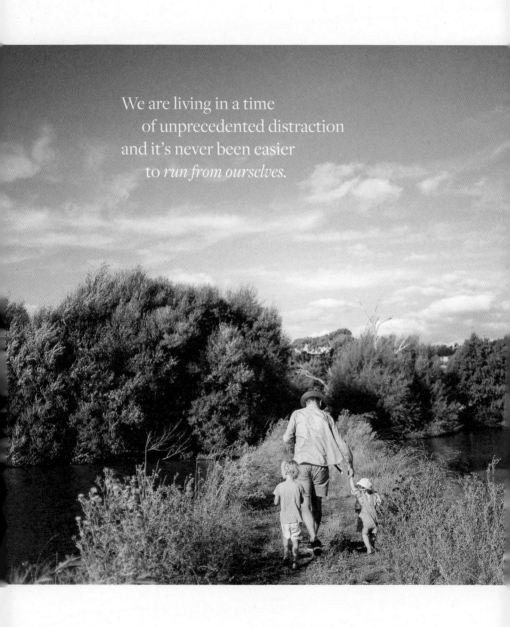

We are living in a time
 of unprecedented distraction
and it's never been easier
 to *run from ourselves.*

Practising Simplicity

Indeed, we've grown up thinking we need to get out of the woods, avoid danger and risk and complication. But I think we need to venture in, hike the physical and metaphorical trails, and sit in our discomfort. Distraction is not the antidote to despair, intentional action is. And, for me, that's practising simplicity, a little bit each day, making a conscious choice to stay present and aware, even when it's hard—especially when it's hard.

I wonder if distraction is what got us here, to this profound moment of uncertainty and unrest where so many of us feel as though we've wandered from our path? We are so caught up in the noise and the race, we are carried along on the tide and perhaps we feel so far from our ground that we're really not sure what matters to us anymore. What do we really care about? The only way to get back to our ground is to consciously stop, turn around, and walk in the direction that feels best and right for us. This is what happened to me on the day I agreed to live in a caravan. I'd done my best to distract myself from the growing unease of complacency, because on most days the alternative seemed far too difficult. But then I birthed my fourth child, a girl named Marigold, born on the day of the adventurer, explorer, or so says a zodiac birthday book that I own and which, coincidentally, has been incredibly accurate for all of my children. Once she was in my arms, I felt a very distinct completeness and throughout the haze of those newborn days—a precious blur of milk and tears—we both emerged as different versions of ourselves.

The Japanese have a word for this unity of heart, mind and spirit: *kokoro*. If I could describe the day that we decided to do the trip, and the voice that said 'yes', I believe it came from a place where my thoughts, feelings and conscience spoke as one.

It was an act of rebellion, but also necessity. And while I wasn't running away from danger or disease, I knew that in order to reconnect, I needed to embrace a new level of uncertainty on a path that took me far, far away from my comfort zone. Of course, I had to sit in the discomfort of uncertainty first, which is never easy, but it prompts you to think and grow and, ultimately, uncover your own truth. And instead of pining for a life I didn't have, scrolling to search for answers, I set about creating one.

Buddhists believe that our sole route out of suffering is to pay attention, figure out what truly matters and then live life accordingly. If distraction pulls us away from ourselves, from our ability to listen in to what we need and connect with others in meaningful ways, then simplicity can bring us back to our centre. The very essence of simplicity is intentional focus: the ability to slow down, stay present and pay attention and, in doing so, live and do what feels right and good for us and for the planet. Simplicity sees value in wasting time, in getting lost in our intentional abandon and letting the mind wander because it's here, in this space, where we create, explore and question. It's in the quiet that we get to know ourselves and figure out what's meaningful and true.

The world is so noisy that we've grown scared of the quiet. We scroll to avoid silence in the grocery store line, or when we can't sleep, or when we're at a café waiting for a friend. But what if you purposefully sat in it and wrangled your awareness back to the moment without reaching for a phone? Sitting in intentional

We live in a world that glorifies multitasking
 while research proves that it is a practice that
actually destroys our ability *to pay attention.*

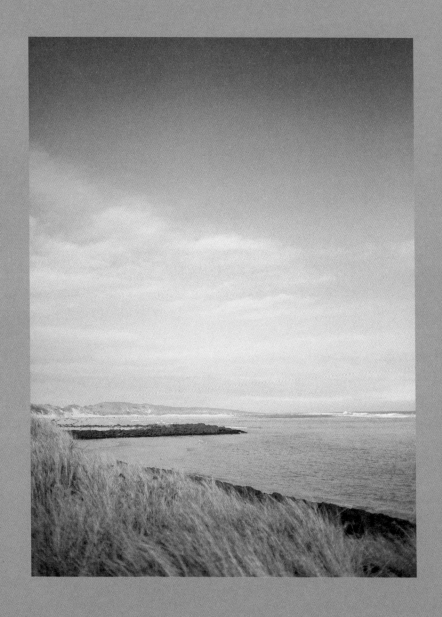

Practising Simplicity

silence is a ritual known in Sanskrit as *mouna*, and I practised it every day at the ashram when I studied there in 2006. After the evening meal we were encouraged to walk to our rooms and observe our thoughts in the quiet silence. There was no social media at that time, no mobile-phone reception either, so at night there were only the possums on the roof, our thoughts and, eventually, sleep.

We broke *mouna* after breakfast, once we had sipped tea and eaten porridge and walked into a new day. But perhaps what was most interesting about this practice is that I, and the people I shared the space with, were hesitant to talk because all of a sudden our chatter seemed unnecessary, like we were filling gaps that could have stayed spacious. Of course, as the day unfolded we would let that hesitancy fall away and engage in conversations but, come evening, we would start the practice all over again. We spent two weeks fostering this ritual and when we left the ashram what was most apparent was the noise of daily distractions and obligations. The world is very, very loud.

I know we are not monks in caves, living in solitude to seek enlightenment. And though we may occasionally crave the quiet of a cave where no one asks us questions or demands a prompt email response, we also understand that distraction is part and parcel of life as we currently know it. In this ever-connected world, it is easy to blame technology for our distraction when, in fact, it's our reliance on it, our love of it, that is at fault. Our brains are hardwired to seek new information. It's a primal response for us to respond to the onslaught of news and shiny updates that flood our screens each day. That's why it's so hard to switch off from the virtual distractions and focus our attention on what really matters to us. This is where our awareness steps in and we ask ourselves: how do we want to spend our time? How do we want to live?

Social media is just a new kind of clutter, pulling us away from the moment and prompting us to want and crave and compare and judge. We can have the convenience and connection that modern life offers us, but we must also accept and take responsibility for the distraction. So where is the sweet spot where we live less distracted without feeling obligated to always pay attention? I think it begins with intentional focus and, for me, that's a reminder on my phone each morning that reads: make a choice. It prompts me to remember my privilege, come back to my intentions and ask myself what I'm going to do with my day. What am I prioritising and what am I letting go of? What is the work that needs to be done, and the distractions I can ignore?

When we choose simplicity we choose to limit our options, which means not exhausting ourselves with decision-making scenarios that inevitably cause our anxiety to rise. I do it with social media, so I'm not exhausting myself with people and businesses to follow and consume; so the voices don't get too loud and the photos too misleading; so I can yield my distraction instead of falling mindlessly into the perpetual scroll. Apart from an intentional hiatus at the start of every year, I've logged on to Instagram most days since it began. It has been one of the most valuable parts of my creative and professional life, connecting me with mothers and creatives who I now consider lifelong friends. It would be dishonest to discuss the doom of distraction without acknowledging that I have used social media to bolster my own business and, essentially, distract others with my photos and words. Yet, in recent years, I've been particularly focused on the way it makes me feel, its addictive qualities and the sheer amount of times I reach for it, regardless of where I am and what I'm

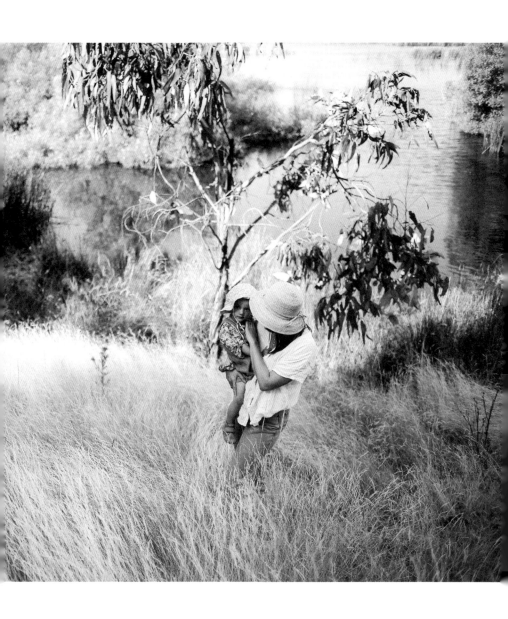

doing, even if I don't intend to check in. (Ironically, I've reached for it countless times while writing this chapter, which only proves that distraction is powerful and I haven't yet tamed it; despite my choices, despite my intentions, the temptation exists.)

Social media is the kind of distraction that informs and deludes in equal measure. And while it is now a profoundly powerful marketing tool—an unsurprising capitalist development—it has unprecedented power to spread news and inspire action, and to gently remind us of what matters and what doesn't. I find a strong human connection via Instagram, connecting with those who are on their own creative journeys, the travellers and the vanlife enthusiasts, those seeking to learn more and listen intently, a community of people sharing thoughts, advice, grievances and angst—those who are like-minded and those who challenge me to think and look outside my bubble.

We can refuse to kowtow to social media; instead, we can take hold of it and use it with intention, as a force for good, so we can still connect, learn and inspire without falling into the depths of avoidance and distraction. That

said, at times I've relied so heavily on social media that accessing quick snippets of information have made me lazy. I realised a few years ago that I was losing the ability to write more than a peppy paragraph or two. I couldn't stretch that creative muscle to convey more than a few connected thoughts, and it was confronting. I also had trouble reading anything of length; the essays and books I used to consume fell by the wayside and my short-term memory suffered. My reliance on social media had reduced my ability to read anything of depth and to retain that information long enough to toss it around, digest it and consider it. I blamed baby brain for a while there and, while I genuinely believe that my creative brakes were on, in part, due to the growing, feeding and raising of four children, I would be lying to myself if I didn't recognise my reliance on the quick-fix of social media. But I'm not the only one. Research posits that our attention spans are shortening because of our pressing need to multitask and stay relevant. We dash from one news grab to another, scroll from one voice to the next, glance at a picture and read a sentence before we move on, promptly forgetting what we just consumed. News bulletins are now delivered in punchy dot points, and we tap our way past anything that makes us feel uncomfortable or confronted because that is the ease of our connected, disconnected lives.

Practising Simplicity

The cure was simple: I needed to do the creative work of getting my brain going again, and strengthen my reading and writing muscles—because my handwriting was flailing, too. It was clunky and messy and it took me a long while to find my flow again. So I started writing three pages a day to find my rhythm—a stream of consciousness to get to the root of things—and I reached for books instead of screens and challenged myself with lengthy reports on the climate crisis and news features that required my concentration, focus and, at times, my courage. And I realised that reading and writing is ritualistic for me, it's my joy. It allows me to process and question, mull and create.

Our brains were not designed to do multiple tasks at once and while it's commonly regarded as a symbol of success, multitasking actually reduces our productivity. What if you chose to focus on a slower, more mindful path forward, which is gentle, focused and also fulfilling? A simple lifestyle, concerned with the imperfect and the impermanent, the one that often requires us to make do and get creative, to be patient and present, is a slow revolution calling on those who are overworked and overwhelmed to shed the unnecessary and get intentional. To pay attention to what matters and ignore what does not.

My children pull me into the moment all the time, the littlest ones who tug at my skirt so I stop what I'm doing and pay attention, marvel from their perspective at the world and snap into the present. When they do this I'm reminded of the sobering truth that children grow, time flies and all we have is now. I know here, when I do pay attention to what matters, when I spend time looking at the sticks they've lined up, the dead bird they've found on the sand, the white moths that dance on the water like fairytale sprites, that my choice is clear: I choose to live less distracted. But that's not to say that

I don't find the good in distraction; I actually believe it's an integral part of life and creativity. It's where we question and ruminate, make plans and consider opportunities. It's also where we see—truly see—what is surrounding us. Pay attention to what matters, and get distracted by it.

'We look before and after, and pine for what is not,' wrote Percy Bysshe Shelley in 'To a Skylark', his ode to the songbird, a symbol of aspirational happiness. While we may live complex lives in an increasingly agitated world, we also know that the most direct route to contentment is to live less distracted and focus on what matters, to stop pining and start living. To very consciously come into the present moment without sparing our attention so we can feel it all. When we do this, we are more likely to savour each moment and cherish it for what it is. And move on with a renewed sense of both purpose and faith—in ourselves and the world around us.

Distraction is two-fold: it is the ease we succumb to when we reach for our phones, mindlessly scrolling instead of dealing with discomfort, and it's a soothing salve that pulls us away from our concerns. On the flipside, consciously allowing ourselves to become distracted by the things that matter reminds us of the good and beauty in the world. We all need a distracting balm for these troubled times. Choose wisely.

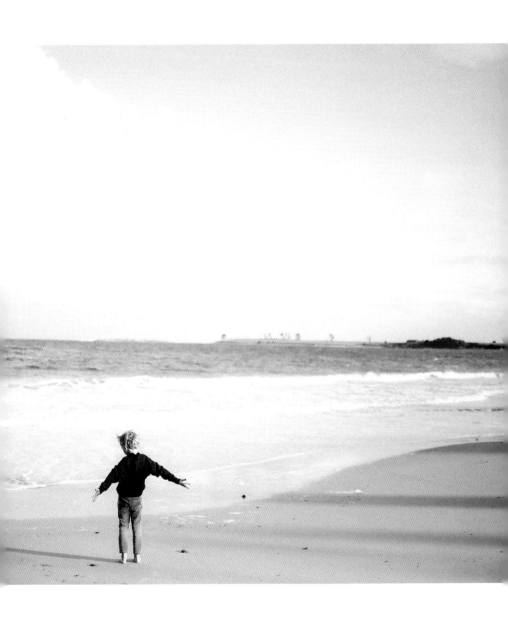

A life less distracted

Chapter 9

This present
contentment

Mole Creek is about as small as a small town gets in Tasmania. Tucked into the base of the Great Western Tiers in the upper Mersey Valley, it's both unassuming and blatantly beautiful. There are cottages with rose gardens and the biggest daisies you've ever seen on the main street, and small farmhouses dotted along the dirt roads that stretch into the valley. The fields are vast and green, home to cows and sheep and hundreds, if not thousands, of pademelons, and then beyond in almost every direction are mountains: tall, strong and commanding.

There's hardly anyone here—just the locals and a few visitors on their way to Cradle Mountain, who stop in town to buy locally harvested honey and check out the Tasmanian Tiger display at the Mole Creek Hotel, painted paw prints on the footpath leading the way. This is tiger country, and woven into the town's story is a history of thylacine sightings despite there being no official records of the carnivorous marsupial since 1936. Regardless, these stories continue to be shared because mystery and curiosity have carried the most far-fetched tales for decades, from town folk to mainland nomads. It's intriguing to even the most disinterested that this elusive animal may still exist in the deep wild of the Apple Isle. Once you're here it makes sense; there is so much dense wilderness, rugged mountain ranges and deep valleys—the hiding spots are endless.

We arrived on a warm afternoon after spending three hours on the side of the road waiting for the car to start. When we pulled into Mole Creek Caravan Park, we weren't sure if it was the best place for us, such is the perspective of a worn out, frazzled and hangry travelling family. To play it safe we paid for one night and parked up the furthest end of the park, a grassy field behind us and Mount Roland beyond.

This present contentment

As soon as we had unhitched the van and put the kettle on, the kids were knee deep in the creek and building dams with stones. It was midsummer and if you took away the cool breeze that blew over the mountains in the west, it was hot. The sun in Tasmania bites and while most think it's because the hole in the ozone layer is right above the Apple Isle, others believe it's got a lot to do with the clean air. Tasmania often records the purest air quality in the world and less pollution means fewer UV filters. The air in Mole Creek is startlingly clean; it's part of the reason I love being there so much. Nothing pulls you into the moment like joltingly cold, fresh air—which, in Tasmania, you can still experience even in the height of summer—and the desire to tilt your head and breathe it deeply and fully, to fill your lungs and your soul.

The kids spent all afternoon with new friends, two girls who had been strangers five minutes before. Watching these fleeting friendships forge on our journey has been a highlight; they know not to waste time so they connect within minutes and delve into play, often for a few hours before they have to say goodbye. Travelling families naturally gravitate towards each other; we understand the complexities of road life, the challenges of only ever being with siblings, the excitement when there are other kids at the camp when you arrive. The questions are always the same: 'Where are you from?' 'How long have you been on the road?' 'What's your end date?' And then there is the inevitable discussion of must-sees and secret free camps, caravan parks with cheap washing machines and the best roads to take to get to where you're going.

The afternoon was peppered with tea and conversations, wet kids and sweeping gazes across the landscape. By evening we had extended our stay for five nights and as we settled into bed, the three hours we had spent on the side of the road, stressed and frustrated, had faded. We had the mountains in the distance and the creek beside us, bellies full and children sleeping, the caravan curtains filtering the moonlight that was so much brighter than anywhere else we'd ever been.

It was the most rejuvenating,
 affirming experience:
to be grateful for the moment
and also *recognise the path*
 that had led me there
—the fear, doubt,
 challenge and trust.

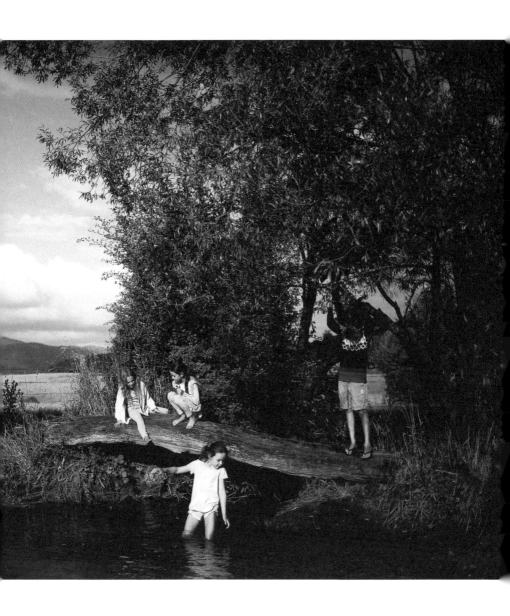

This present contentment

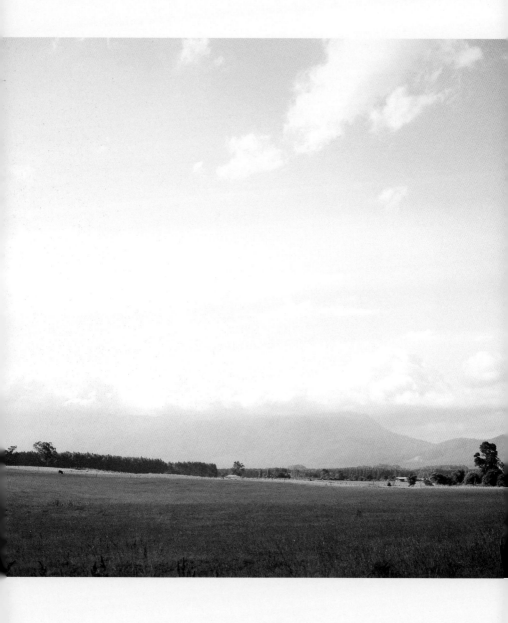

Practising Simplicity

We returned eight months later on our second trip to Tasmania. The weather was a little different; unseasonably cold winds were coming from the south-west and they were frantic and icy, despite it being late spring. Seasons can be flippant in Tasmania; there is a long winter and, hence, a drawn-out anticipation for sun and warmth and bare feet. No one packs away their woollens because you may need them, even in January when the calendar says midsummer but the temperature gauge disagrees. We parked up against a row of pine trees for protection because wind is not your friend in a caravan; we've had too many nights of being rocked from side to side, the walls shaking and rattling. On those nights I do wonder if a decent gale could topple us over, so we've learned to check the forecast for wind, park near windbreaks and never, ever put the awning out if there is any chance of anything more than a pleasant breeze because chances are we'll be pulling it in at 2 am, clad only in our pyjamas, and if it's raining, soaked through and cold.

The summer tourists were yet to arrive in Tasmania so Mole Creek was quieter than our first visit and when the kids were rugged up in the van watching an afternoon movie, the silence was startling. Daniel was studying so I made a cup of tea and went to the edge of the field. The sky was clear apart from a few veiled clouds that draped themselves around the mountain top like bedsheets on a clothes line. Mountains have such a grounding, calming presence, so secure in their stance. It's like they cordially invite you to share in their solidity: come, settle into the ground but stand tall with your convictions, plant your feet, spread your arms, breathe deeply and let the wind whip around you.

Despite the winds that moved quickly over the mountain ranges and down into the valley, Mount Roland in the distance remained strong and still, and I attempted to do the same. Because while many people write home about the benefits of climbing mountains and the moment you reach the top and look out, there is a lot to be said for standing in the fields and looking up to them, energised and settled by their strong, steady presence. It was cold and quiet and peaceful, the air like new, my fingers wrapped around a still-steaming cup of tea. The wind was pushing the grass so it danced across and around the valley, in big swooping movements much like the starlings in their murmurations. I held myself in this moment because what I felt was an undeniable sense of ease and contentment.

After years of striving to attain happiness,
I found it in a country field
and the knowing that I am happy, *truly happy,*
with the very simplest of things, in nature.

This was contentment and it filled me like a warm kind of quiet, soft yet clear. It was the most rejuvenating, affirming experience: to be grateful for the moment and also recognise the path that had led me there—the fear, doubt, challenge and trust. Not one part of preparing for this road trip was easy, but I intrinsically knew that it was the right path, even if my head questioned it every day. I suppose it was listening to what felt most right, for me.

I wanted for nothing in that moment and it was such a poignant reminder that when we dig deep enough to know what really matters to us, away from the loud, social conversation of consumerism and influence, we can find our contentment and do things every day to make sure we know it, feel it, stay in it. When I mention Mole Creek to people, when I talk about the beauty and

This present contentment 183

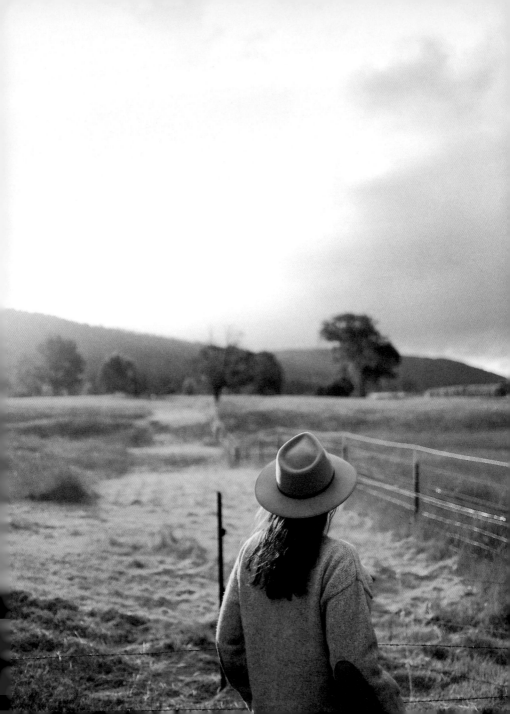

contentment I find there, they often look at me, questionably. To many, Mole Creek is merely a mark on the map with all the standard features of a country town in northern Tasmania. And I suppose that's exactly it: to me, it is remarkably ordinary and, therefore, truly lovely. It's a valley of grassy fields and dirt roads, with mountains all around. The purity and simplicity of this place, with its fresh air and clear sky, may seem mediocre to some, but I find it rather charming. It calls me into the present moment, to be fully alive and awake to everything around me, and to tune in to how I feel and think in the midst of it all. I'd found this place as a consequence of the path I'd chosen for myself, and I was living, very consciously, in it.

I think of that moment in the field often, especially when I feel overwhelmed and heavy. It's not something I grasp for or cling to, but it sits in my mind like a Post-it note on a page, and it's there to guide me to what's important when I get distracted by what isn't. When I get caught up in what we don't have, when I fall into fear about what's coming next, when I worry about the future and our fragmented world, I just take myself back to that simplicity: the field with the long grass and the big sky, with the wool socks and the cup of tea, the kids quietly watching a movie and dinner in the oven, the promise of a good book to read and a warm blanket to snuggle under. It's a picture of deep contentment and I was there, in the midst of it, my house a home on wheels, my feet firmly on the ground, my face lifted towards the sky. Breathing deeply, living wholly and fully and gratefully in the present, alive.

Chapter 10

A weary world needs a garden

and a library

My dad has a ceramic plaque nailed to the gum tree in his backyard. It's the kind you find at garden nurseries, beside the gaudy gnomes and novelty wind chimes. It reads: 'When the world wearies and society does not satisfy, there is always the garden.'

It's been there for as long as I can remember, a permanent fixture that rouses little attention and is now branded with the patina of eucalyptus sap and cobwebs. And yet, whenever I walk past it I read it out of habit, reciting the words without ever having to look at them as I continue on to the compost at the back of the garden near where the chooks scratch and graze, their white and ochre plumes speckled with dirt. They are not words that particularly resonated in my younger years when my world was rather small and predictable. But I witnessed, on many days and through many seasons, the reprieve the garden offered my parents, the solace they found as they tended to the herbs, the vines and the roses. The way they would sit, in deck chairs or on the back step, a cup of tea in hand, looking out to the garden they had grown, quietly contemplating.

'Weary' is an apt word for these times. We are, as the Germans say, *Weltschmerz*: melancholy about the inadequacy and imperfection of the world. We are all feeling it: exhausted from the deep and relentless tiredness of uncertainty, one that has such breadth and depth that it's palpable as we walk down the street. The imperfection of the world has rattled us and yet, when it comes to gardening and to nature in general, there is no such thing as perfect. In all its phases of growth, its bare winter shell, its abundant summer crop, there is life, continuing on, content in the ebb and the flow.

Beyond the back step of our house, the one I grew up in, the one my parents still call home, is a ramshackle garden on a typical suburban block. There are many troublemakers here: bandicoots that dig up a lot of what you plant;

Practising Simplicity

lorikeets and cockatoos that screech and squawk from the gum trees above before they puncture the almost-ripe tomatoes and steal grapes straight off the vine, leaving an acrid mess in their wake; possums that eat most things; and the moths and slugs that will feast on all manner of leaves.

The herbs and blooms grow so high under the Hills Hoist clothes line that when you take bed linen and long dresses off it, they have been brushed with the scent of rosemary and lavender. When I wasn't swatting my legs for the mosquitoes that plagued us in the humidity, I would bury my face in the hot, white sheets that smelt of summer and earth, the occasional gum leaf caught among the folds, and breathe deeply. The garden was in bed with me on those nights, when the cicada chorus was loud and yet somewhat comforting. The flutey warble of magpie song would wake me on those mornings, when it was already too hot for sheets, a blanket of summer air carried from morning till dusk. Of course, I grew up with contempt for the garden, too: for the fly-swathed compost that repulsed me, for the trailer load of elephant poo that would inevitably arrive in the driveway come summer when the circus was in town, and for the blood and bone fertiliser that I could smell from halfway down the street.

For most of my childhood, I watched my dad from the kitchen window amble from tomato vine to vegie patch, pruning and watering and tending his plants. And while I enjoyed the results of the many months tending soil—the cherry tomatoes that oozed summer sweetness, the rocket that added a peppery punch to the salad, the potatoes that would inevitably meet their match with salt and butter—I could see that it was the

therapy of the process for Dad. When he was defeated by snails and ransacked by possums, the possibility of his plot spurred him to continue, but it was the quiet of moments found in the vegie patch that bookended his days. A bountiful harvest may be rewarding, but regardless of the success or failure we reap, gardening is a schema for thinking about life.

In her book *The Well-Gardened Mind*, Sue Stuart-Smith explores the garden-psychology connection and says, 'A garden gives you a protected physical space which helps increase your own sense of mental space and it gives you quiet, so you can hear your own thoughts. The more you immerse yourself in working with your hands, the more free you are internally to sort feelings out and work them through.'

Before we left on our road trip a friend mentioned that she could never live nomadically, for the simple fact that she would be without a garden, a grounding patch of dirt and the opportunity it presented. I didn't think much of her words at the time but as we journeyed further into our trip, I felt the pull of green spaces.

On the travelling days that went awry because of car troubles or agitated children or misjudged distances (and the inevitable fallout over alleged navigational skills), the discovery of a garden quelled the chaos and the tempers. I soon learned that there's not much that can't be fixed by a sandwich, water, a cuppa and a short nap in a green space. We would picnic under shady gums and, more often than not, we would read and nap there, too—much-needed rest before we drove on to someplace new. I started to search out gardens, places to retreat to when we needed a break from the road, a green reprieve when the stark light of the highway hurt our eyes. These green spaces and parklands are thriving in cities and small towns, intentionally planted as breathing spaces among the buildings. They are also magnets for community, purposefully planted by the neighbourhood,

Practising Simplicity

a gathering spot that slowly becomes, with time and care and intention, a gracious offering. These community gardens did not ask anything of us but welcomed us mere strangers and shared everything they could offer. Granted, in many cases we stumbled upon them when they were empty—quiet places where we could wander and think, play and shriek, lift leaves and vines to find edible treasure that we would pick with gratitude to the growers and the soil, the sun and the rain. I definitely wasn't growing anything in these places but I benefited from those who had, with forethought, time and effort, planted according to moon cycle or season. Perhaps they were just coming together to create an abundant patch of food for themselves, but I saw each garden as an offering to those who visited for quiet, reprieve and hope—in the community and in the plants that sprouted under its care.

Gardens are so much more than plants growing in the earth. They are the efforts of those who have planned and looked forward, who have knelt on the earth and dug with their hands, listening, watching and connecting. They are years in the making or perhaps only days old, and they are a magnet for communities who want to come together on the earth to commune and grow. We were strangers in the places we visited and yet these gardens were welcoming spaces for us to peruse and pick and to find our ground when the transience of nomadic life had shaken our nerves and tired our bodies. We found gardens everywhere, tucked into little alcoves of caravan parks where herbs and silverbeet grew in abundance and we were encouraged to please, take what we wanted. The roadside honesty stalls, the give what you can, take what you need movement, the botanical gardens where we spent an afternoon on the edge of the Stuart Highway before we ventured into the Red Centre where the wattle was in bloom: sunshine confetti against the red dirt of the desert.

I found my fascination with community gardens extended online, too. I started following homemakers who shared their charming vegie plots more

for their own documentation and note-taking than for the likes they inevitably received. I watched old episodes of *Gardening Australia* (the show that we would religiously watch at 6.30 pm every Friday night growing up), and I scrolled back to see one woman's progress on her picturesque English allotment. I didn't have any soil to tend for myself, but I found just as much joy and satisfaction watching others grow their gardens and it prompted me to search out market stalls and locally sourced fruit and vegies at small-town grocers on the roads we drove from one town to the next.

I bought mint and garlic from a garden plot in Bicheno. The kids and I meandered through the community garden that sits next to the library in Daylesford, and we left gold coins in an honesty box in exchange for pineapples from a roadside stall in Queensland before we drove further into the cane fields and towards the Fraser Coast. On the Fleurieu Peninsula in South Australia, I discovered a local organic fruit and veg' delivery service and, when the box arrived in a red van, out stepped Lou, whose eyes glinted warmth and we stood chatting, in the icy wind that regularly pummels Victor Harbor, talking caravans and good food and motherhood.

Bruny Island offered a fridge at the turn-off to Sheepwash Bay that was full of sourdough loaves, freshly baked, still warm. On that day, when the sky was low and the air bitter, as it so often is on Bruny, the delight of an old fridge packed with just-baked bread was of the truest, most undeniable kind. We raced back to Bruny Boathouse—the little cottage by the water we were staying in—and slathered slices with butter and jam, then ate them down with hot tea, gazing out to the boats on the D'Entrecasteaux Channel that separates Bruny from Tasmania—an island off an island off an island at the bottom of the world. My friend Steph, a fellow mainlander who had taken her own leaps to settle in a 1910 homestead on a hill in the Huon, gifted me a jar of homemade peach jam and we ate it in an old farmhouse not far from hers, where the long grass growing up and over the hill led to a swing where we could see what felt like the whole world.

Rosemary flourished in the garden of Raffah House in Oatlands—a heritage sandstone home on the main street that was once the maternity hospital—and we added it to roasted potatoes and kumara and carrots, popped a sprig in a celebratory gin and, later, wrapped twine around a bunch to hang in the

van and carried it with us into Covid lockdown. Its distinctive woodiness provided comfort and mental clarity while the world seemingly imploded and we sought shelter in a light-filled rental that would become home for the next six months (and was, surprisingly, a cheaper option than many of the caravan parks we had stayed in on the mainland). In those first few weeks of lockdown, when our lives felt like a strange dream, a new friend dropped a small box of just-picked herbs and greens and a jar of summer honey at our door and it felt like a hug. A few months later, another jar of honey and five varieties of homegrown garlic were delivered via post and, when housesitting for friends in Devonport, we boiled eggs straight from the chook shed and gasped at the golden yolks that oozed as the kids dipped in toast soldiers.

These small joys are simple ones, but I remember how I felt when I found the bread and again when we cracked the eggs. They were joyous enough moments to file away for later and memorable enough to write about here. And as we settled into life in Tasmania once lockdown lifted, we started to notice the best patches of blackberries to forage, the elderflower bushes that bloomed in spring, their flowers begging to be made into cordial. I started paying particular attention to fellow Tasmanian gardeners who planted their crops at very particular times, wary of frost, the unrelenting westerly winds that regularly pummelled the island, and the possums and pademelons who graze in their own rather productive ways.

The decision to live in Tasmania was not a quick or conscious one, but the longer we stayed there, the more it felt like the best place for us to be. This little island beckoned to us, got under

Practising Simplicity

our skin and it continues to charm. One year on, and I am still disarmed by the fresh air and the yellowing grass, the sea glass and the mountains, the quiet expanse—the sheer, wild beauty of it all.

These pockets of joy were found wherever we travelled, and I have no doubt that you could find them, too, in your neighbourhood, if you look. Because there is always the garden, there is always the park at the end of the road and the grass in the backyard. There are community gardening pages on Facebook and notes pinned to community noticeboards advertising seedlings to share or zucchini to take, because there is only so much zucchini slice, fritters and relish one can eat in summer. In fact, on the day we went to the children's new school in Tasmania—the first time they would attend school after two-and-a-half years of Distance Education—we were offered a homegrown zucchini along with book packs and information sheets. It's a special thing to be given something that has been tended and cared for, and I hoped in that moment that my children would receive a similar kind of nurturing as we put down roots in a new town.

Gardens may offer quiet and also joy, but I also believe they can offer us hope, in change and growth and things not always going to plan. I believe that we can all find solace here—in any green space that invites us to sit without judgement or expectation. Because the world is a noisy place, don't we all need somewhere quiet where we can hear ourselves think? To have time to consider our thoughts before we are roused, interrupted by noise or question or obligation. I sought out those quiet spaces on the road, when the reality of living in a small space with four children felt overwhelming, when I grew tired of the clothes and food that would tumble out of the overhead cupboards as I opened them. I found the quiet underwater, when I swam out alone and floated with my ears under the surface, closed my eyes so the bright light shone through my lids. I found it on the rocks of an evening when everyone else was tucked up in bed and I had an hour to watch the sun set and listen to the wind coming in off the coast.

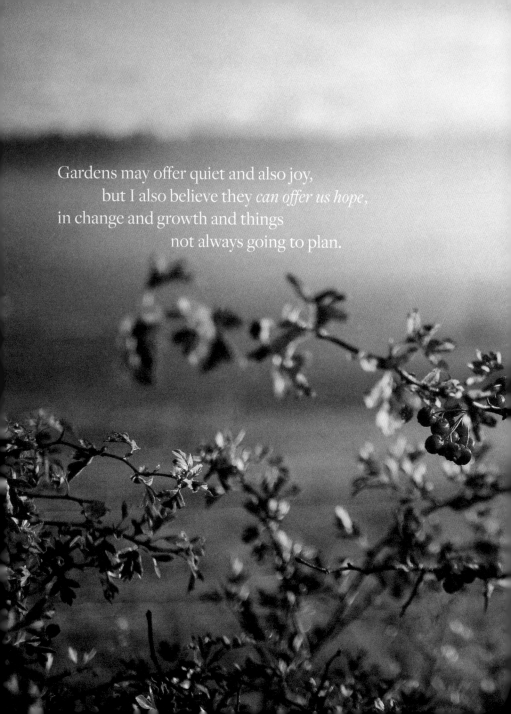

Gardens may offer quiet and also joy,
but I also believe they *can offer us hope*,
in change and growth and things
not always going to plan.

Sometimes I found it in libraries, when I could go there alone to read and write and find a sense of camaraderie with those who were doing the same.

Libraries became a welcome, hushed refuge for us, when the heat or the dust or the rain pushed us inside, when we needed the space of a large building and the comfort of books, we would go there and settle in for a few hours. Regardless of where we were, we were greeted by enthusiastic librarians who often took the time to chat with us, offer craft activities to the children and didn't blink when our one-hour visit turned into a whole afternoon. On one particularly hot day in northern Victoria, we discovered Wangaratta Library, housed in an old building with high ceilings and huge windows, and the sticky, sweaty limbs of my children left my side as they pulled puzzles and books from the shelves and punctuated the quiet with their exclamations. The librarian handed us paper and colouring pencils, and a roll of compostable garbage bags, a new initiative from the local council. And, while it might sound strange to find happiness over a roll of garbage bags, this gesture of kindness was really practical for us at the time. We had run out of bags and were discovering that it's very tricky to shop in bulk and actively reduce your plastic waste when you are a large family living in a small space, wary of the size and weight of everything you carry.

Many of the pages of this book were written in libraries and, on many mornings, I was joined by a group of white-haired gentlemen who came together to read the newspapers in mostly silent companionship. There would be an odd quip here and there, a mutter about a wife at home, plans for the afternoon

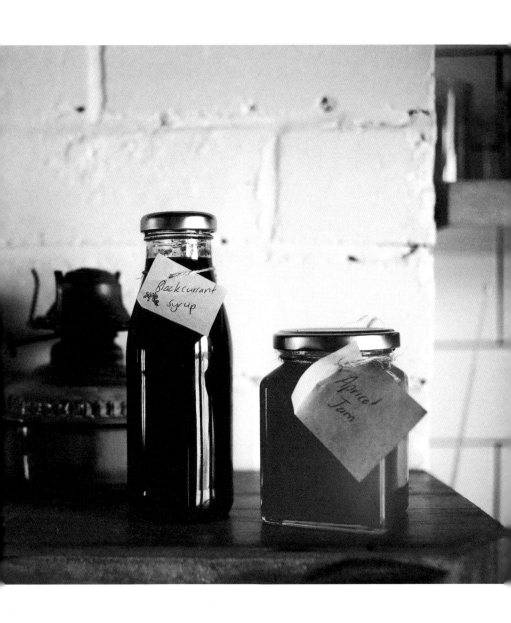

A weary world needs a garden and a library

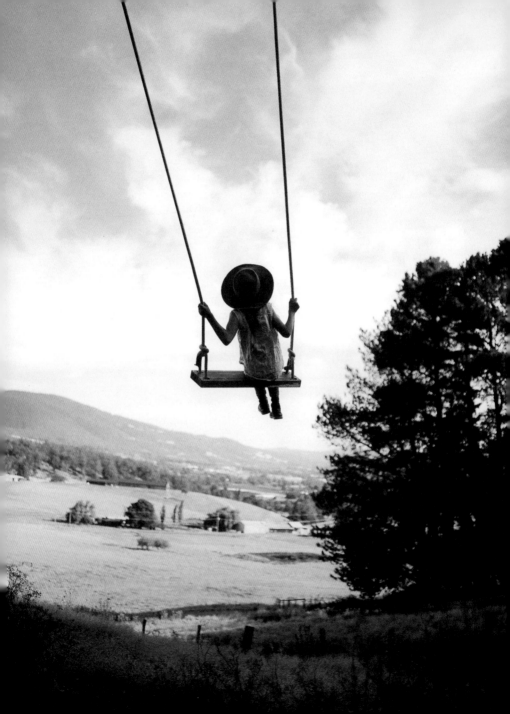

playing bowls, but mostly just the clearing of throats and the turn of pages as they glanced from top to bottom, left to right. I sat within earshot and we never spoke, but I felt a strong sense of community in that space, a shared understanding for a quiet space to read, think and write.

I purposely visited libraries in many of the towns we stopped in and I like to think of them as indoor gardens: community hubs that welcome everyone to grow and learn and seek assistance when life is tricky, and when it's not. They are safe havens for families and children, particularly in the younger years when song and rhyme time fills the air with words we all know and remember from our own childhood. For the homeless and the vulnerable, they offer support to those seeking financial counselling or navigating the complex legal system. And, for many, they are simply a place to rest in the quiet of a comfortable chair with a book and no judgement. During lockdown in Melbourne, the Yarra Plenty Regional Libraries knew that the elderly of their community would significantly miss the connection found within their walls. And so, each librarian was sent home with a phone and a list of numbers and they worked their way through, calling on every member aged 70 and over to check in and have a chat—all 8000 of them. They connected them with other community services, or sometimes just talked about the troubles of the world and how they were feeling amid it all. Because sometimes that's all any of us want or need, isn't it? A good chat with someone who cares, stranger or otherwise.

Despite the blatant fragmentation of the past few years, I think there's been a common thread for most of us as we've navigated life throughout a pandemic and the reality of our climate crisis: it's hard and confronting, and it feels like the uncertainty may just unravel us. Yet we keep going, alone and together, one foot in front of the other. And to do so we must have hope in what's to come, in the changes we make and the lives we live. Even if it's as simple as placing hope in the seeds we sow and the books we borrow.

Chapter 11

Habits and rituals

Our daily habits anchor and shape our lives. They are our non-negotiables, the things that carry us from one hour to the next, through seasons and years. We may scoff at them but we find comfort in their predictability, too. And even when life is overwhelming and we flail, we can rely on a cup of tea in the morning, pegging the washing on the line after breakfast and the sweeping of our muck and mess from the floor to bring us into the moment.

As Gretchen Rubin says in her book *Better Than Before*, 'Habits are the invisible architecture of daily life.' They represent our intentions and values and, as our priorities shift, so too do our habits. In fact, if we want to make change in our life, we start by changing our habits. Simple living is a series of considered habits that you choose to embrace and you'll find, with time and awareness, that one habit naturally leads to another as you learn and gain momentum. But also, as you plunge deeper into a lifestyle that makes ecological and economic sense, you start to see the connection between the way we live each day and our long-lasting footprints on this earth. Our habits are meaningful; they guide us through the week, but they also have far-reaching repercussions beyond our homes.

Simple living may be a path less travelled, but if the research is correct, it's also very necessary. In fact, it's the only way forward, the only way we will preserve and sustain our life on this earth. You might start with washing your re-usable coffee cup each night and putting it in your bag ready for the next day. You'll soon learn that it's best to meal-plan and shop to a list so you buy less and waste less. When you're out of food and need to go shopping, you might decide to put it off for one day, and then another, and realise you can actually make quite a good meal out of what you thought was a bare fridge. Next, you'll find yourself remembering your net and cloth bags for the shop

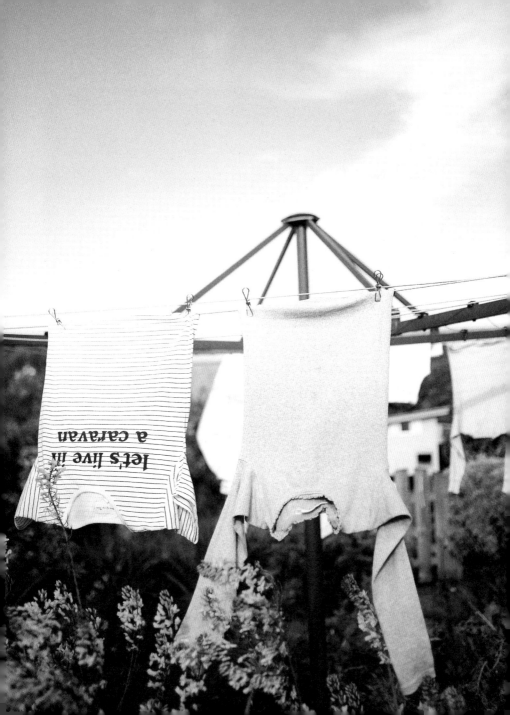

because you don't want to use unnecessary plastic ones, and you search out grocers and markets that don't wrap their produce in plastic and invite you to bring your own containers and jars. When your can opener breaks you head straight to the op shop and, while you're there, you find a woollen jumper that you'll put on in late autumn when the chill sets in but before you're ready (or willing) to put on the heater.

Confronting news reports may be a catalyst for you to make change, but you'll soon discover the joy and fulfilment of meaningful habits and it's this joy that will permeate your life, prompting you to keep going and share your new-found pleasure with those in your orbit. You'll also realise that grand gestures won't save the world. It's the ordinary habits we perform each day that make lasting change. If you're critical of this mindset, let me tell you about food waste. If the food buried in landfills were a country, it would be the third largest emitter of methane in the world. And it's not the farmers or the supermarkets or big business or the cafés on the high street that are at fault. It's us. In Australia, we waste one-fifth of the food that we buy; we just throw it away once it's passed its expiry date, starts looking a little alien or has grown slimy in the bottom of the fridge. But reversing our food-waste habits can reduce the amount of waste in landfill and, therefore, the greenhouse gas emissions that are released into the atmosphere. So yes, our habits matter.

In 2020, many of us fostered new habits when we had more time at home to consider all the things we do each day. We filled our time with the things we usually reserved for rainy days, holidays, the elusive days we hoped would emerge in the middle of our busy lives: slowing down, checking in on our neighbours, planting gardens and watching them grow, reading books, relishing in the changing of the seasons, resting regardless of the time of day or day of the week. When time and existential concern were abundant, we learnes to see the significance of what we did each day. And we found the joy, right in front of us.

On the road, as we travelled from one place to the next, sometimes not knowing where we would be sleeping that night, my habits grounded me in the transience of nomadic life. When I felt particularly anxious or unsettled, I found comfort in the normal and the necessary, the ordinary things I did each day regardless of where we were and in spite of the plans that went awry. I was forced to consider our proximity to the grocery store, keep a close eye on what we had stockpiled in the cupboards and the freezer, and only put clothes into the washing basket if they were really, truly dirty (washing machines in caravan parks and laundromats are expensive, especially when you're doing three loads at a time). Like so many travellers who uproot their lives and live in a caravan, we had to be frugal, but I found purpose in that, too, and discovered an undeniable pleasure in getting back to basics and not wanting more than what we had.

I eased into each day with my habits: sipping tea while stirring porridge, handing out steaming bowls to sleepy children who cried, hungry before they'd opened their eyes, lighting a stick of incense and placing it in the hole of a shell I'd found on Willyama Beach in South Australia, hanging washing and hoping the sun would bleach the red stains of pasta and dirt. While some may say that our daily habits are merely necessary things to see us through, I find purpose in them.

When we ponder how to live, we're asking ourselves what we believe in. Me? I believe that the slow and simple days make us our best selves, for it's here, in the remarkable ordinary, that I find meaning and hope. I believe that our choices and habits can amount to big change, and that we are responsible for the way we live, and the repercussions of it. I believe that opportunities for happiness and hope exist right here, right now, not at some time or place in the future that is accessible only after we've accomplished and conquered everything else. As the words engraved on the path leading into Cradle Mountain - Lake St Clair National Park say, 'The abundance of life is beneath your feet.'

This alpine national park is a world heritage site, a wild landscape of ancient rainforests, golden buttongrass moorlands, snow-capped peaks and deep valleys. When you walk on the dirt paths, deep into the land, you feel like you're at the end of the earth. And you are, in a way. This little island off an island at the bottom of the world is rugged and remote and one path leads from the north to the south, calling on the most intrepid hikers to walk and sweat and marvel. You can't help but feel in awe of the intricacies of this intriguing landscape, the way it pulls you in, begs you to come a little closer, to look a bit longer, to breathe it all in and never forget.

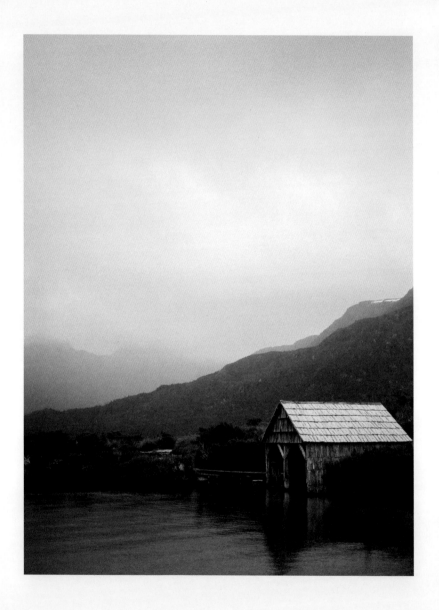

Practising Simplicity

We were there in spring, when there was a smattering of snow on the mountains but only frost and ice on the ground. We spent three days at Dove Lake, looking out to Cradle Mountain. The weather changes quickly and drastically in this part of Tasmania, so despite the season and the forecast, you go prepared with jackets and boots, water and a plan. One afternoon, as we sat by the lake while other tourists came to take their photos and left minutes later, we threw rocks in the water, watched a currawong steal crumbs of birthday cake and sipped tea from a thermos. The clouds rolled in and the sky changed from stark alpine blue to a soft grey, cloaking the valley and us in its cool air. We started to pack up, gathered children and memories and, as we walked back, the rain fell like soft sleet and I lifted my face to it, feeling it, drinking it, being it. I said, 'It feels like a spiritual cleanse,' to which the kids replied: 'It's just rain, Mum.' And I suppose that's just it, isn't it? We can choose to believe in the beautiful ordinary lives we live or we can pine for what could have been, what's yet to come, what we don't have, what we've left behind.

My daily habits often took more time and forethought on the road. When we did a load of washing we needed to find gold coins for the machine, wait for a machine to be free, string a line from the van to a tree or a fence and hang the clothes out to dry with the pegs that often went walkabout on shared caravan park washing lines (my lost pegs were always replaced a few stops on, when I'd find them discarded on the ground or left by another traveller long gone). But when I did load the washing machine and later hang the clothes out to dry, there was often another traveller there to chat with and I found that while our conversations were fleeting they were beautiful, too. These connections, based on daily habits, allowed me to see how connections were so often made in our villages, when the architecture of our daily life coincided with that of our neighbours.

When routines change and our sense of what's sure and true falters, we rely on rituals to bring us into the moment. To comfort our weary minds and

broken hearts and to draw us towards the ground so we can steady ourselves—quite literally, but also figuratively. Rituals are, ultimately, an act of kindness, and they start with intention.

Through many years of motherhood, I learned to make a ritual of the quiet of the evening, when the noise had abated and, despite the mess of the day left in its wake, I was free to sit still and think. I, like Mrs Ramsey in Virginia Woolf's *To the Lighthouse*, could be myself, by myself. 'For now, she need not think about anybody ... to be silent; to be alone. All the being and the doing, expansive, glittering, vocal, evaporated.' It was in this quiet darkness that I made plans, packed boxes and leaned into trust when fear punctuated my thoughts. It was a nightly ritual that led me from one week into the next and eventually on to new adventures. On the road, when everything was new and equally daunting and exhilarating, I learned to rely on the simplest of rituals for comfort and stillness—a long walk on the beach when we arrived in a new coastal town to unwind after an exhausting and stressful drive, reading a story to the children before bed, bringing my awareness to my breath before I fell asleep, breathing deeply into my belly to ground and settle me. I can see now that those first few months of travelling were the tentative first steps into a new season of life, and like all seasons—new babies, new homes, starting school and changing careers—we fall back on our rituals because they steady us when change feels like it may just unravel everything.

Many moons ago, on a solo trip to Paris that didn't quite live up to the fanciful ideals I'd jetted off with (in part due to homesickness but mostly because of the sense of panic and doom that I know now as anxiety), I sat in the pews of Notre

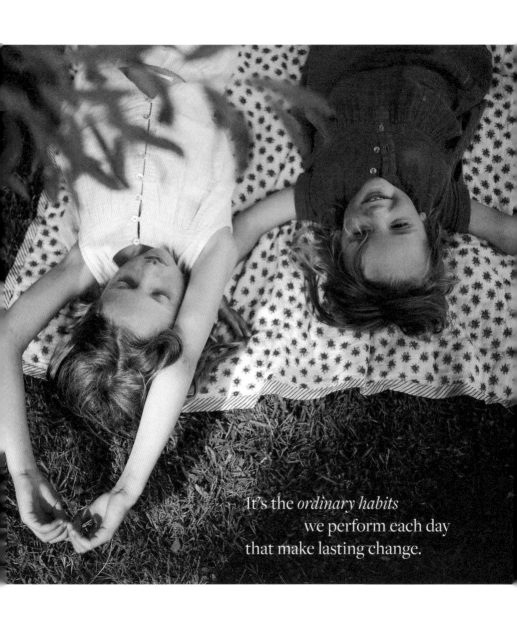

It's the *ordinary habits*
we perform each day
that make lasting change.

Practising Simplicity

Dame because it felt like the safest place to be. I watched as a steady stream of tourists and the devoted stepped up to light candles, one after another. Each person stood in stillness for a moment before moving to the side and making space for the next person, the next prayer. Others bowed to the flame before walking off, some took a seat at a nearby pew and sat in reverential silence. I remember thinking that regardless of our language or religion, when we light a candle we stop in a moment of intention. In churches and places of worship, on altars and birthday cakes, a burning candle represents our primal need to remember, reflect and celebrate. There is beauty and reverence in the flame and the light, in this ancient ritual that honours time and place. For many of us, the lighting of a candle signals the end of the day and the coming together at the dinner table, a ritual as common and as precious as they come. We light candles to welcome the unborn and grieve the dead, to bring light into the midwinter home and to celebrate the end of one year and the start of the next.

We are captivated by flame, whether it is a solstice bonfire, a winter wood heater or a small fire we create for toasting marshmallows while camping. I feel the same about a boiling kettle, particularly the whistling kind on a gas stovetop. And while I don't want to get too saccharine about tea, I can't deny the anticipation of a cuppa as I patiently wait for the kettle, dunk the tea bag, watch the tannin colour the water and take that first sip, eyes closed, momentarily grateful. I get excited about it, like I do a new book, like I do the promise of a solo swim in the ocean or a bath late at night. Rituals always have a purpose, but they also offer us reprieve because they help us create space for reflection.

Living in response to the seasons reminds us to pause and reflect, too. In autumn, like the deciduous trees, we shed the bustling busyness of summer and start to retreat. But this only happens if we allow it, if we intentionally welcome that reprieve and create the pauses in our life to embrace it. When

I make stock, I take stock, and on slow midwinter days that signal the change of season and the passing of time, I find my mind bubbling along as the golden liquid in the pot does the same. Rituals often take time and forethought but they bolster us, too. They are not grand or complex, and they don't require too much of us. In fact, you'll soon learn that the simplest of rituals, the ones you can so easily take for granted, are actually some of the sweetest experiences you can have in life. Ask any camper or hiker or nomad how good a hot shower feels after a week without one and they will recall the anticipation of the cleanse, the moment the hot water hits their head and the feeling afterwards, of being wholly fresh and renewed. The same goes for a sit-down meal shared with friends or the harvesting of tomatoes from a vine warmed by the summer sun, or the quiet of the night beside a fire as you look up to the velvet sky and the stars and remember that magic exists, if only we look for it. And sometimes, amid the chaos of life and family and demands, it's closing the door to your bedroom and lying like a starfish on the bed, shutting your eyes and reminding yourself that there's no need to rush, that life isn't an emergency to attend to but an experience to sit in and soak up.

In a world that glorifies the hustle and the drive, the brilliance of better, and encourages us, rather endlessly, to perfect and complete, I think we need to value what Joan Didion calls 'the repeated rituals of domestic life', for the simple fact that they make up our days, they are there regardless of season or location and despite their ordinariness, their very mundane nature, they ground us, remind us of what matters. As Didion writes in *The Year of Magical Thinking*, 'Setting the table. Lighting the candles. Building the fire. Cooking … Clean sheets … These fragments mattered to me. I believed in them. That I could find meaning in the intensely personal nature of life.'

There is nothing grandiose about clean sheets or lit candles, but when we think of them we are reminded of the small yet meaningful comforts that we seek when we are weary and disenchanted, and even when we're not.

Rituals always have a purpose,
 but they also offer us reprieve
because they help us
 create space for *reflection*.

But rituals are not only there for comfort. I think they fill a void when we opt for a simple life where we consume less and connect through the things we do rather than the things we accrue. The traditions we create for ourselves and our families bring us together by pulling us into the moment. And whether we see it or not, it is these traditions that make up our most precious memories. When I reminisce about our travels, I remember the places we visited and the things we experienced, but the simple moments that unfolded every day are the ones I hold closest. What special memories we were making when we didn't realise it at the time, for we were just sitting in the van eating breakfast or driving to someplace new with the windows down and the music up or coming together at the end of each day, dinner on the table, night falling, the stars above us and, often, a duck or a sparrow or a seagull catching crumbs at our feet. When the children were asleep I would often go back outside and seek the quiet and just sit, alone, thinking of nothing, content in quiet awe of the black sky and silence.

In her book *Women Who Run with the Wolves*, Clarissa Pinkola Estés says: 'If we establish a regular practice of intentional solitude, we invite a conversation between ourselves and the wild soul that comes near to shore.' Stepping out into the night became a ritual for me, a form of solitude and also rest from the noise and the questions. Rest is a ritual and also, strangely, a revolutionary act in this age of hustle and drive. We live in a culture of urgency, and consciously stepping away from it requires us to prioritise rest. Indeed, it's an integral part of a simple life where we consciously step off the imposing conveyor belt and wander along at our own pace. When we rest we're giving back to ourselves, honouring the frayed nerves and tired adrenals that pulse and race, allowing them to settle and slow, so we can let go of the distractions, tune in and pay attention.

'Let go' is a phrase I've uttered countless times over the past decade. I encouraged my yoga students—young men and women with anxiety,

pregnant mothers, retirees opting to move gently after long periods convalescing—to sit or lie down and let out three long, whole body exhalations. And then mentally repeat to themselves 'let' as they inhaled and 'go' as they exhaled. It was always clunky for the first few breaths but as I sat cross-legged on the mat and scanned the room, it was like the whole space breathed again. I watched shoulders relax, furrowed brows soften and tears fall. Letting go brings to the surface our most vulnerable selves because we let everything else fall away until it's just us and our breath, in and out, no longer forcing or rushing but just being, in stillness. I practise this form of intentional rest most days, often in the middle of things, and especially when I feel like I'm flailing. It's in these moments of conscious settling and connection that I think about the naptime and bedtime rituals that I carve out for my children—the considered steps I take to ensure they are warm, comfortable, fed, watered, soothed and gently guided into sleep. But this is a kindness we generally don't reserve for ourselves. For many years I fell into bed fully clothed, anticipating a restless night of waking and feeding. But I started to see a bedtime ritual as a beautiful way to guide myself into sleep, even if sleep was elusive. It was my way of carving out space for intentional solitude, despite the evening obligations, despite what the day had uncovered, despite what was expected of me tomorrow.

Many years ago, before I understood myself the way I do now, I used to go out every day so I could feel productive. If I left home and went to do something—anything—I settled the agitated part of me that believed I'd achieved because I had done something with my day. What I didn't realise was my everyday trips out and about left me tired and simultaneously wired. Rest may be a resistance to the paradigms that keep us rushing and doing and succeeding, but when I learned to rest, I got to know myself and began to ponder how to live. I learned to listen to my family's own rhymes and rhythms, to feel the difference on the night of a full moon and a crescent, to sense the shift of light as the days grow longer and the stark white winter light mellows, deepens, is richer in hue.

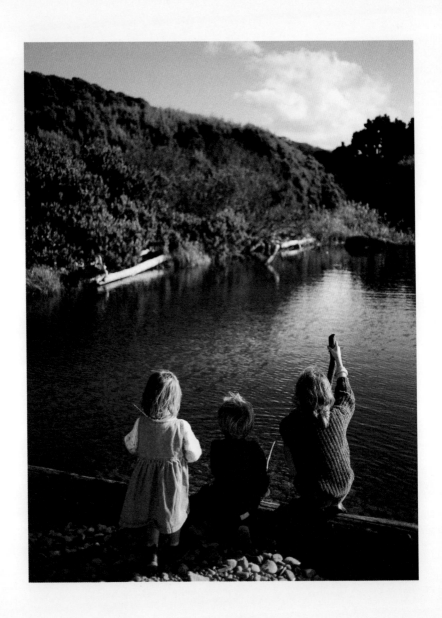

Practising Simplicity

Rest is, like many things, a matter of intention and practice. And often we are inspired to seek out rest and find intentional pauses when we realise how fleeting and precious time really is. I am sure that any mother will relate when I say that by the time I had my third child, no amount of dishes or distractions could pull me away from the sweet newborn curled into my body as we lay in the afternoon sun while the rest of the house clattered and shrieked. You're allowed to slow down, it's okay to nap when you're weary. To pause what you're doing, stop pushing through the deep exhaustion and succumb to what you know you need. Resting in the middle of things—as life swirls on around us—honours our physical needs and invites space to pause and tune in to the things that really matter.

Imagine if we all gave ourselves permission to rest in the middle of things, when the sun is high and when it's not, in the mid-morning or the late afternoon, on weekdays and weekends and holidays and normal days. Sometimes that feels far from possible. But think for a moment: what if you intentionally paused, for just a day? What would happen? You would start to notice the sprinkling of pauses from morning to night that already exist, and moments where you can create them. You could, if you wanted to, grab hold of those pauses and bask in their stillness, in the opportunity to stop, feel your feet on the earth and think only of your breath. And as you connect in these moments, you'll start to pay attention to the tiny precious things that exist all around: the patterns on the leaves, the trail of ants, the pulse of the ocean, the giggles of a toddler.

There is nothing simpler than our habits and rituals but that is precisely why they matter. They strip away the superfluous, bring us into the moment, and encourage us to find the purpose, joy and contentment that exists in our ordinary lives. One by one and collectively, our habits guide us forward, on to the night and into a new day.

Chapter 12

Tell me
your story

When I was young, I drew the same picture over and over again: a house with a pitched roof and a quaint garden path leading to the edge of the page. Despite never living in a house with a wood fire, I always added a chimney with a plume of smoke and if I was feeling particularly generous, two pots bursting with yellow flowers on either side of the front door. It may have been a series of connected shapes requiring minimal ability, but by repeating these patterns I was celebrating the archetype of home: the restful shelter where we find comfort from the wild, bitter winds of life, and where the future waits and everything is possible.

In this time of great flux, home has taken on a new meaning for many of us. We've been forced to find hope within our walls and purpose in the simple habits we often take for granted. A house may represent a place, but home stands for belonging and it's a sense of belonging that can be our greatest comfort when life is uncertain, when we struggle and thrive in often unequal measures. And while we may be dismayed at the world and exhausted by the relentless challenges that face us, we have an opportunity to choose possibility and joy. It's there regardless of what is happening outside our windows and while it may, at times, seem frivolous in the face of the unknown, it can also be our guiding force. As we navigate life, we can lean into the simplest of things to rest and recalibrate, to muster energy and perspective and to remind ourselves that we can choose our own adventures, if we want to.

Stories are the language of our lives. And while living in a tiny home on wheels has taught me many things, it has also proven to me that the houses in which we live soak up the stories we write there. I've always considered heirlooms and keepsakes to be the tangible things we pass from one

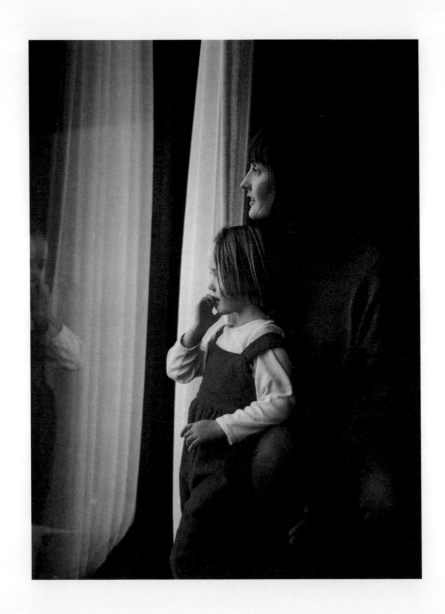

Practising Simplicity

generation to the next: handmade patchwork quilts, an antique tea set, a piece of jewellery representative of love and marriage in one generation, a promise in the next. But the real keepsakes are the stories they represent, the ones we carry with us in our hearts and minds, the ones we share with each other.

Since becoming a mother, reading stories has become one of my favourite daily rituals. I feel a sense of belonging with the bedraggled mothers and jam-faced, delighted kids that feature on the pages of Shirley Hughes' picture books. I've read *Peepo!* by Janet and Allan Ahlberg enough times and to so many children that I nod to the mother asleep in the easy chair and know her exhaustion and happiness. And on all those nights that I read *Are We There Yet?* in the lead-up to hitting the road, it was Alison Lester— the author and mother—who I thought about most. I thanked her in person, when we visited her studio in Fish Creek and saw her sitting at her desk, ready to meet fans both young and old and sign books. As she was chatting to the kids about all the places we had been and all the places we were yet to see, I realised: one story always leads to another.

As we travelled we stopped in heritage towns to read plaques on the fences of old homes and I wondered about the people who once lived there and the stories they could tell, of how they squeezed eleven children into a tiny room, then fed and washed and soothed them in the very same space. If our homes are full of stories, an invitation to visit feels all the more precious. Before we hit the road, we had been told about the travelling community and the willingness of other nomads to share advice and lead you from one destination to the next. And it's true: wherever we parked there was someone willing to have a chat. But one of the best invitations I received came in the form of an email and a bold yet chipper introduction: 'You don't know us but we've been "following" you for a long time. We are Sarah and Emma, sisters from South Australia.'

They wanted to let me know that if we ever found ourselves on the far south coast of the Yorke Peninsula, we were welcome to stay in their holiday home—a beach shack with plenty of beds and puzzles, an outdoor bath and a coffee machine. I immediately adored them, not only for their generosity but also because of their lively sentences, their willingness to share, their admission that they were just regular people in a rather performative online space. I call them dear friends now and I know they are anything but regular. They are golden, creative lights in this world, salvaging all that has been discarded and giving life to old homes, championing lost stories and creating spaces for new ones to be made.

Nine months after that email exchange, we drove south from the desert and swapped the red dirt for canola fields and salty air that hit us with such force that when we inhaled our sinuses instantly relaxed. The desert dries your whole body but we hadn't realised how deeply we were affected until that moment when, with dry hands, parched lips and a thirst for the sea, we were reminded of our love and need for the ocean.

The towns got smaller the further south we drove but it was the verdant green hills against the blue sea that stunned us. We'd grown so accustomed to the rich, red land that witnessing spring's abundance was all the more beautiful; even the weeds looked romantic. The little white shack beckoned us with its bathtub and simple comforts, which, when you're living on the road, really are as simple as a washing machine and a flushing toilet. It was raining when we arrived in Marion Bay, a small town that sits at the entrance of Innes National Park and, as we opened the door to the cottage, we were instantly charmed.

The house is undeniably beautiful but before long you realise that what you're feeling is a stirring of the heart. The walls hold the stories of summer holidays and family gatherings, and you can't help but dream and plan and wonder.

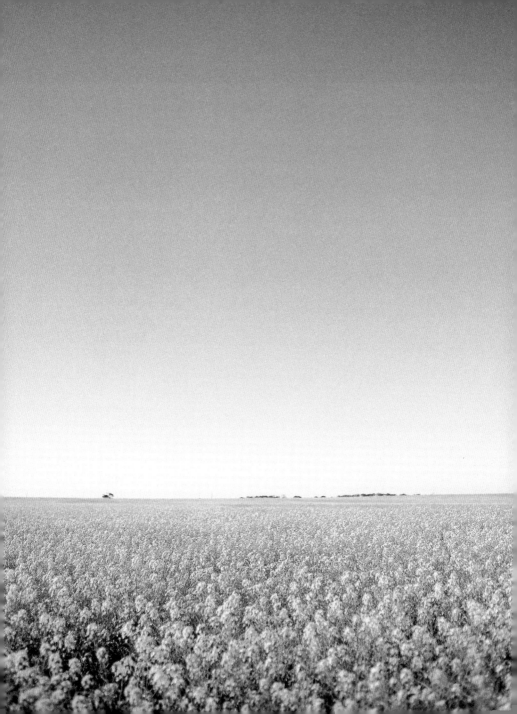

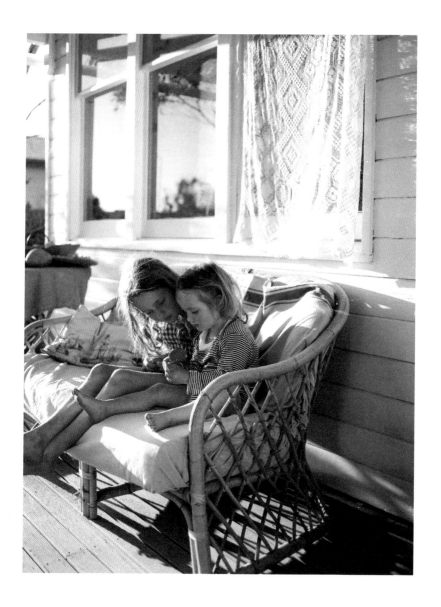

Tell me your story

Everything that has been placed on a shelf has been done so with intention: old artwork, collected shells, a sprig of this, a gathering of that. There's a magpie that has the audacity to wander into the kitchen and catch crumbs from the little girl sitting on the bench eating toast. You light the fire with pine cones that have fallen from the tree down the road, the afternoon sun shines straight through the yellow curtain in the kitchen and the whole house glows like the canola fields we passed to get there. Simple, joyous things.

This little shack is found in one of the southernmost points of South Australia and it's imbued with Sarah and Emma's story: rich with found treasure, spontaneous adventure, colour and texture and love. It's an ode to their sisterhood and their mother, the woman who would squeeze roadside furniture into the car with four sandy children on summer days—they had no choice but to contort themselves around chairs and table legs to make it home.

Some houses ruffle us, stir up all the thoughts and feelings we may have ignored and make us face them head on; they haunt us until we listen. Others invite us to stay a while and settle in, put down roots, hang pictures and make memories. Houses, like stories, are safe places for us to seek solace and quiet. It's here where we rest and learn, and where we first think that maybe, just maybe, we could change direction, embark on something new. When we believe that there is hope in our habits and our homes, in the things we do each day, anything seems possible. And for me, sitting in our last home, the one that brought my discomfort, fear and complacency to the surface, I realised that I wasn't so much seeking change as I was time. The crux of our decision to travel, to sell most of what we owned and live nomadically in a caravan, was not to see the country or tick places off the list. It was simpler than that. We just wanted time—to spend with each other, growing and learning but mostly just being, together. We wanted a whole year with our kids before their childhood evaporated in a rush of school mornings and lost lunch box lids. It was always about time because time is all we have.

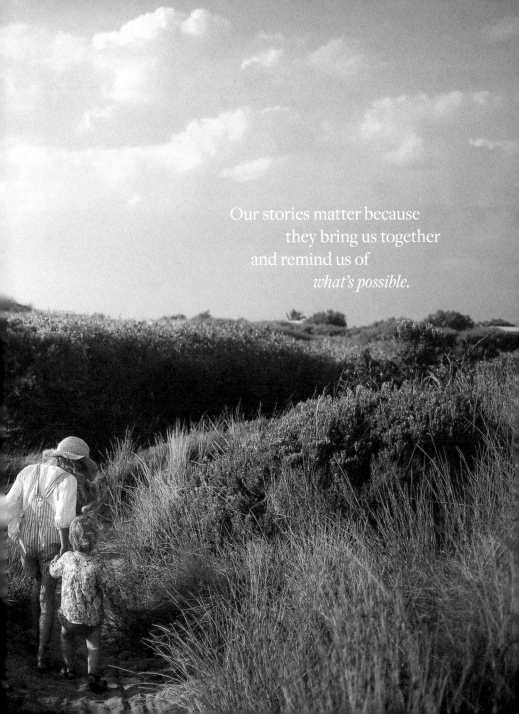

Our stories matter because
they bring us together
and remind us of
what's possible.

Practising Simplicity

As we sat in that little white cottage by the sea, ten days of no plans stretched out in front of us and we tossed around ideas for where we should go and what we should do next. An invitation to return to Tasmania for the summer arrived and we leapt. That decision was more profound than we realised at the time, for it led us to our new home on the Apple Isle, in a little town where the mountains meet the sea.

Our honest stories, the ones we make each day and carry along with us, they are all valid. And sharing them in all their imperfect glory is essential for all of us in our messy humanity. Wherever we are and however we live, our stories are worthy of being shared. And perhaps what we need most at this time are not stories of great success or conquering, but of simple progress and connection. As environmentalist David W. Orr writes in his book *Ecological Literacy*: 'The planet does not need more "successful people". The planet desperately needs more peacemakers, healers, restorers, storytellers and lovers of every kind.'

The real stories are in the ordinary progress we make each day, in our homes and communities: small tales of triumph in a vegie garden or a well-risen loaf of bread, a beautifully crafted sentence or a new shade of blue for the bedroom wall. Sometimes our greatest feats are listening in, surrendering to rest, being gentle. Of learning to see change as a possibility and not a grim, fear-filled unknown, of getting comfortable in the discomfort of quietness and, sometimes, getting lost so we can find our way forward. After all, as Rebecca Solnit says in her book *A Field Guide to Getting Lost*, 'Never to get lost is not to live.'

She explains it as 'a voluptuous surrender, lost in your arms, lost to the world, utterly immersed in what is present so that its surroundings fall away'. Are we all willing to embark on full-bodied adventures, those that stir a sense of purpose, remind us of what matters and what it is to hope? This sounds so big, but really, it's being prepared to focus on the small things, the

simple things, and let everything else fall away. This may just be a sure-fire way to practise simplicity and find joy in what already surrounds you, which isn't so much about getting lost but losing yourself in the beauty: of nature, of life, of living—in your home and in the world. I'm guided by the belief that a simple life—one that honours the natural world, values time and celebrates the beauty of the ordinary—is the most affirming, fulfilling one for me. It's the one I choose.

We are settling in Tasmania for many reasons, but the clean air, distinct seasons and slow pace definitely drew us in, kept us intrigued, and allow us to live in a way that feels good and right and true. And when I do get caught up in the what-ifs, I think back to everything I've learned over the past few years and know that simplicity, even in the face of fear and uncertainty— especially in the face of fear and uncertainty—grounds me and reminds me of what matters. I know that there is profound beauty and encouragement in the mountains and the sea, comfort in a homemade meal at the end of the day and curling up with a book once night falls. There is purpose in making choices, every day, that are good for me and for the planet. I know that I'm most content when I have the opportunity to ramble, to walk windswept beaches wrapped in wool, to spend time without rushing to the next thing and to live slowly and purposefully.

Our youngest has spent the majority of her life in a caravan and she's rather wild as a result. But her wildness is not the agitated kind. With feet planted firmly on the ground and an intuitive sense of wonder, she is both content and resilient; she exudes a happy kind of calm. But if something doesn't feel right, she'll remark with conviction and the occasional (hilarious) eyeroll: 'No way!' She cares not for offending or disappointing, simply for saying what feels right. Perhaps we need to grow accustomed to saying no to the choices we've made that no longer align with what we believe in. I think that's how we write our own stories, the ones that matter, the ones that carry us onward.

Every day is
an opportunity
for choice and change.

Once you've said 'No way!', you may like to ask, 'What now?' As Ann Patchett said in her rousing 2008 essay *What Now?*: 'What now is not just a panic-stricken question tossed out into a dark unknown. What now can also be our joy. It is a declaration of possibility, of promise, of chance.'

My 'what now?' became my biggest most wonderful change. In an increasingly anxious world, where we escape into screens to switch off and tune out, we need stories to remind us that we aren't alone. That there are many of us making changes, failing, trying again, living ordinary lives in ordinary homes and holding on to sparkling glimpses of hope when the world is particularly weary. Our stories matter because they bring us together and remind us of what's possible: that on the very same day we can be rocked by grief and simultaneously seek joy in the small moments is not a fanciful ideal but just very, very normal.

How to live is such a pertinent question for our times. And I think if we have the opportunity to consider it and really mull over our options, we're starting from a position of both comfort and privilege. After years on the road, what I have gathered about joy and belonging is that we feel most content when we find ourselves. It's not so much about where we live but how we live, wherever we are. And in the how is our beliefs, our intentions and our story—a story that's always worth sharing.

Epilogue

'You must go on adventures
to find out where you belong.'
— *Sue Fitzmaurice*

I've now watched all four seasons come and go in Tasmania, noticed the light change and the leaves fall, basked in fleeting summer days and been quietly charmed by the bitter winds that blow in with almighty force. Despite the rousing gales there is a slow and steady pace here because the locals like it that way; there's no need to hurry. Community is the Tasmanian way and we've been welcomed into its fold; we bump into people we know on the street and we've found friends that feel like family. I love that I can buy my apples from a big wooden crate at the local grocer and know that they were picked from an orchard over the hill. Same goes for the blueberries, the rocket, the pumpkins, the beans and the purple garlic. I often see the potato farmer pull up outside the fruit and veg' shop, and he unloads boxes full of dutch creams, pink eyes and kipflers from the back of his ute, a dog patiently waiting on the passenger seat. As we close our travelling chapter, we're settling here, on this little island where I feel an undeniable sense of belonging. I think we've found home.

Acknowledgements

This book was completed on Tommeginne Country in lutruwita. I pay my respect to the elders past and present—the first storytellers.

I will always be grateful for the conversation we had that day, Lou Johnson. Thank you for guiding me before the words were even on the page.

To Jane Morrow, I adore your energy, your insight and the fact that you read my first draft in the bath. Thank you for championing this book into being and endlessly supporting me along the way.

To Julie Mazur Tribe and Andrea O'Connor for editing with such fine attention to detail. Thank you for bringing such care and consideration to my story.

I knew what I wanted this book to look like and Kristy Allen understood my vision from the very beginning. Thank you to Sharon Misko for working your magic and curating my hundreds of photos into this beautiful collection of memories.

To Alison Lester, for inspiring countless story times with my children and planting the seed for our own adventure. Thank you.

To my creative friends who have taught me so much over the years about life and photography: Luisa Brimble, Tim Coulson and Alexandrena Parker.

There is nothing ordinary about your remarkableness, Anna Davis. Thank you for your support, encouragement and excitement as I rode the ups and downs of writing this book. I'm grateful for you every day.

To Hannah Alexander, thank you for reaching out at a time when I needed you most and for your unwavering support and enthusiasm as I wrote the first draft. I'm so lucky to call you a dear friend.

You took your own leaps and led the way for me to take my own. Always grateful for your genuine kindness and big heart, Stephanie Phillips.

For being on the end of the phone most days, thank you for your friendship, Sophie Walker. I adore you!

To Sarah Hall and Emma Read for your generous invitation to My Sister and the Sea, where the first few sentences of this book were written. But mostly for your friendship, your critiques, your excitable squeals over voice memos.

When the world felt scary, you opened your beautiful home to us, Amanda Colverson, and made our lockdown winter a warm, safe and comfortable one. So many of these chapters began in the window box beside the gum trees. Thank you.

To Mum and Dad, for your endless belief in me, for your constant encouragement, your patience and for counting all those odd socks. But mostly, for supporting and loving us unconditionally. I love you.

Che, Poet, Percy and Marigold, my little adventurers. Thank you for reminding me of what matters, for bringing me into the moment, for all the joy and the mess and the love. I am so proud to be your mum.

To my love, Daniel, for carving the time and space for me to write, for making countless cups of tea and for bolstering me in my writing woes. By my side every step of the way, and for all the days to come.